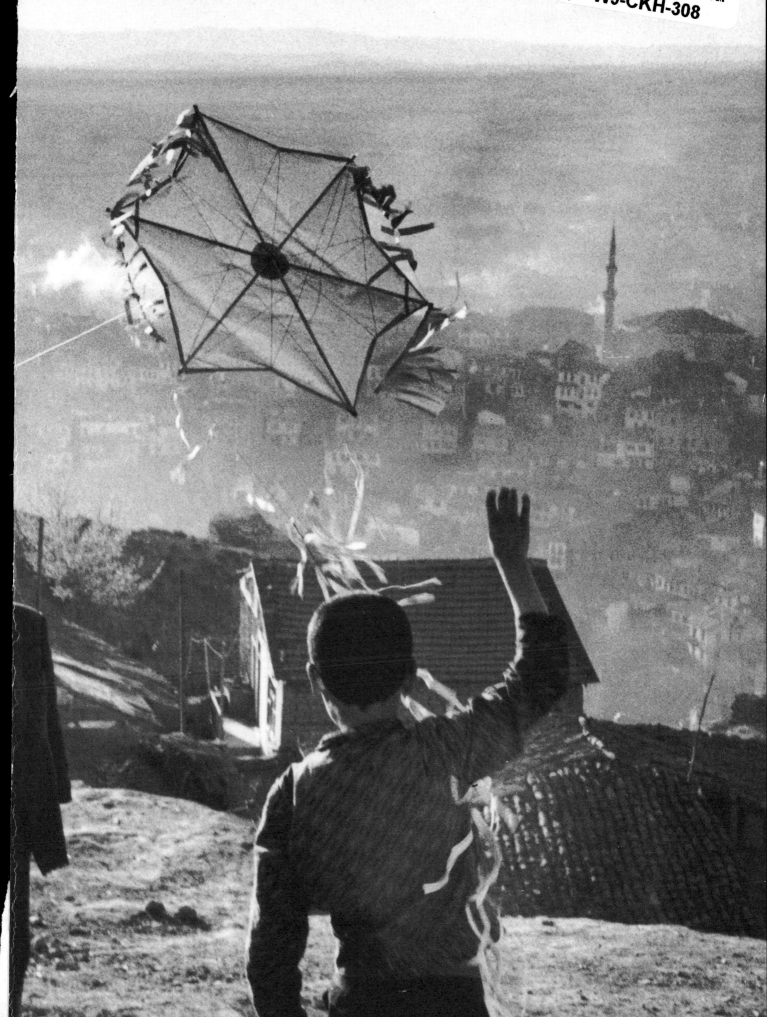

Marc Riboud

I for Imagine

Catherine

Chaine

Translated by Linda Asher

Tara Books

P for Prologue

What kind of alphabet book is this? The alphabet is a very particular organisation of meaning, a way of acquainting the reader—usually a child—with language, objects and associations. *I for Imagine* uses the conventions of the alphabet book, but for entirely unprecedented ends. The reader who is addressed here is not necessarily a child, although older children will enjoy going through this book, particularly with an adult. The words made by alphabets work here as pointers, nudging the viewer towards unexpected ways of reading photographs. They are more than captions, which place images in a context. They are escorts and narrators, free to move between suggesting particular meanings and playing with ineffable associations. They name not just objects, but ideas, reflections, emotions and concepts. Together with the captions, they form a rich web of relations around the image. *I for Imagine* is at once reflective and playful, lyrical and funny, a world of endless stories woven around moments of grace, sorrow and joy.

Sometimes words and images seem to combine in a relatively simple fashion. Consider, for example, *J for Joy*. An ecstatically happy girl leans out of a car. But then we read the caption and realise that the photograph was taken on the occasion of the Algerian independence from France in 1962. We notice the flag that the girl is holding. And the emotion begins to be placed within a particular political and temporal situation, turning into a moment that associates joy not only with everyday happiness, but also with struggle and freedom. The image and the word mirror each other, deepening the resonances of individual, national and historical memory.

R for Road seems quite literal as well. But this is no ordinary road: it is the Khyber Pass, which has determined so much of the Indian subcontinent's history. 'Road' is now in capital letters in our mind, and we pause to take in more of the picture, the wonderfully incongruous handmade sign, of animals and vehicles that have moved along this inhospitable path through past and present.

Other words are more obliquely chosen, one possibility among many—and yet the choice of a particular word turns out to be whimsically apt. *T for Turban* is one of our favourites, as is *B for Bottom*. *M for Mercy* adds a warm inflection to a strong—and justly famous—photograph. *C for Curious*: what could be a more delicious way of interpreting what all these different people are upto? We see, literally, that curiosity is a very universal human emotion, cutting through age and context. Here the visual and verbal meanings act on each other through an additional device: the juxaposition of particular images.

F for Factory and *F for Fatigue* work together as well, and effortlessly manage something formidable—they invoke an entire politics of labour. So by placing the individual photograph into a narrative sequence, image, word and meaning become part of an open ended collaboration, bringing us close to that rare thing: a deeply satisfying experience of the book form.

I for Imagine is a tribute to a way of seeing as well as an expression of it. The photographs featured in this book are from the vast oeuvre of renowned Magnum contributor Marc Riboud. Known for his capturing of what can be called 'the instinctive moment', his vision is strong yet compassionate, managing

to be poetic and gently humorous at the same time. Most of them are of parts of the world as it was in the 1950s and 1960s: Afghanistan, China, Cuba, Ghana, India, Turkey and Vietnam... each of these countries was caught in a spiral of change during this decade and Riboud's eye has kept pace with the changing times, carefully and with much empathy. His pictures of Indian life are both iconic as well as startling: a film director cranking a camera, labourers on a ladder hauling sand and stone, a camel market at the end of a long haggling day, boats on the Ganga in Benares... images which recall both Orientalist timelessness as well as the historic present. In either instance, wrenched from the habitual and the familiar, we experience both pleasure and knowledge. We learn to relish the intense human moment, even as we acknowledge the durable power of the iconic image.

This tussle between the familiar and the new, nostalgia and history, that these photos induce in the viewer is particularly strongest with images from times and places that have since changed dramatically. The eloquent shots of China in the 1950s and 1960s, capturing as they do the pathos, warmth and energy of the vast human drama of the revolution and its aftermath, appear doubly meaningful—their 'real time' emotions sit uneasily with our retrospective knowledge of that nation's history—and we are left with a sense of hopeless wonder. This is true of the pictures from Afghanistan as well—recalling in a way that they perhaps did not for the viewer of these pictures in the 1950s, a world that has not heeded or been allowed to heed its moments of poise and loveliness.

Formally, Riboud's images are perfectly composed, with an unerring sense of geometry. He recalls that when he was young, the great Henri Cartier Bresson told him that the best way to judge the lines of a good photograph was to look at it upside down. These images achieve that formal rigour in an almost inborn fashion, holding form and content in a natural, almost effortless balance.

Riboud's gaze is similar: his camera is leisurely, entranced with beauty but not seduced into ignoring the poignancy and unevenness of lives. He moves gently in time, and what he decides to capture is almost immediately sequenced into history. He focuses unerringly on the historic moment: whether it is images of Algerian independence or anti-Vietnam protests. At other times, the context is not obviously historical at first glance so much as with hindsight, as in his pictures of Ghana and India, with their particular ways of living and being. His version of the 'global'—as we would call it today—is through an evocation of the human condition in all it's variety, historically specific and yet transcending its context.

This way of seeing belongs to a time when the photographer was a bearer of memory, and the photograph appeared able to capture the burden of existential and historical truth (even if it did not always do so). In times like ours, when an exhausting array of images are beamed at us constantly, we are less hopeful or idealistic about representation or truth. Riboud's way of seeing pauses time, if only for a moment, slowing us down to a pace that allows us to stop, observe and relish the moment in all its richness and ambiguity before we deign to capture it.

V. Geetha and Gita Wolf
Tara Books

Introduction

"In theory," grownups write alphabet books to teach children their letters. I say "in theory" because grownups don't always tell the truth. Or anyhow, not the whole truth. In my case, for example, I'll tell you right off: I made this alphabet book for my own pleasure, and yours too—to share the pleasure with you. We should say, by the way, that it's very important and very hard to please yourself, and it would take an ABC book with every possible joy in it to make people a little less sad.

But to get back to our letters. How do these small black marks, lined up in a row like odd little sparrows on telephone wires, manage to make us so happy? Well, simply because they have always joined together to form thousands of words, and with those words we can name everything: what we see, what we hear, what we smell, what we feel, what we love, what we hate, and all the rest. Most of the time, of course, we speak these words rather than write them. If you come across a lion in the street, for instance on the way to school, you're going to shout his name to chase him away, or murmur it to beg him not to eat you, but since it's an emergency you're not going to write to him.

And yet, knowing how to write words with a good sharp pencil or a nice pen can give you enormous pleasure. Different and even greater pleasure than the joy of talking. I can't list all the joys of writing because there are too many, and each of you will experience them in your own way, but as soon as you begin to write, you will probably feel how nice it is to grip a pen in your three fingers and set it to tracing the shapes of letters—very definite shapes. They recur over and over in the world but, drawn by your own hand, they can be recognized among all the letters drawn by your friends because, as soon as you start

writing, you will have "your" handwriting, unlike any other. And you will discover very soon that the words a person writes often come out stronger, more exact, more precious, than the words he speaks, and that there are also words we don't dare say but we can write, words of love in particular. And sometimes, words of anger.

I don't know why I began by talking about the joys of writing rather than about the joys of reading. Perhaps because those second sort take longer to develop, and because letters might not at first look to you like nice sparrows but more like dark, stern, disagreeable eyebrows, frowning in all directions, and impossible to understand. The business of learning to read is often like the huge wave that those kids in Ghana (*W for Wave*) have to get through before they can start catching wonderful fish in a sea all calm and warm, with exactly the right amount of salt.

It was to help you get past that big wave as well that I have put together this alphabet book with Marc Riboud, my favorite photographer, who is also—no secrets—my husband. With him you'll kill two birds with one stone: exploring letters and words, you will also learn to read the world. As you turn the pages of this ABC, you will follow him over the paths he has traveled on foot or on wheels; along with him you will gaze at things he has touched, and loved, enough to pick them out, set them apart, save them, transform them into photographs. The words will turn into images, you will "see" the sadness in the eyes of a young Chinese soldier, the Indian boats in the twilight, the grace of an African girl standing in her cabin doorway. You will discover beauty in places we don't perceive it because that's not where we expected it—in the tangled weeds of a garden,

in a plastic bag that becomes a weird rabbit, in three little girls huddled together against the dust and the harsh wind.

Little by little you will "hear" the pictures, because they speak a silent language like the words in books. From one photograph to the next you will come to understand how Marc Riboud looks at the life around him and at people with humor, with tenderness, and with that astonishment you feel yourself because, as photographed by him, everything seems new, seen for the first time.

And just as he chose to photograph a mischievous little Chinese boy, a teenager dreaming in an Afghani teahouse, or the beautiful gesture of the child launching his kite into the skies above Istanbul; just as I chose the pictures for this ABC book from among thousands of his others, you too will choose "your" photos, and you will remake the world in your own way and to your own taste.

Thanks to these pictures, these letters, these words, you will be that boy washing down elephants in the waters of the Ganges River, or the one parading like a young sultan on the back of the great animal in Jaipur. The sad gaze of the very dignified English woman or the angry look of the turbaned man in Bangkok may remind you of someone you love. To look at a photo is always to recall or invent a story. What's become of the Nepalese boy leaping so happily into the Mekong River, or the little scamp photographing the photographer with just his fingers? What are their lives like? Each one of you will make up whatever you wish in your head or—who knows?—maybe write it, with the letters you learn as you turn these pages, back and forth, dreaming...

Catherine Chaine

A for Acrobat

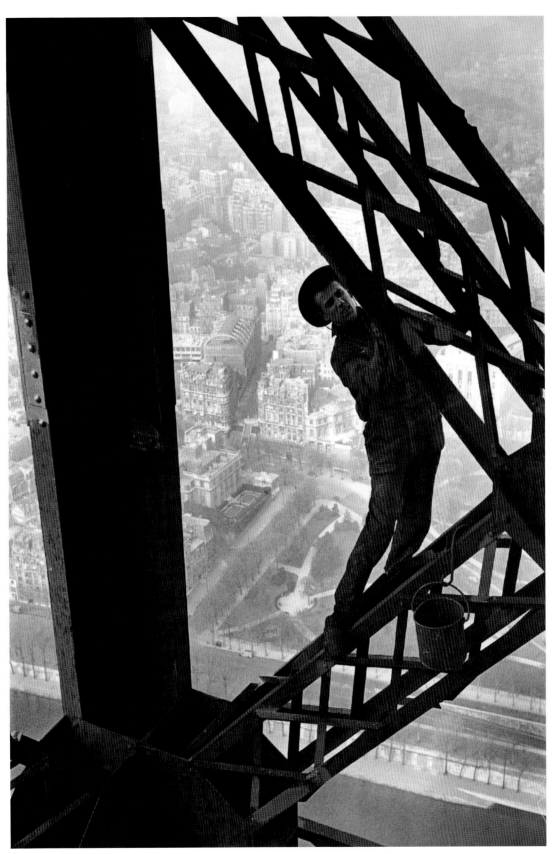

Paris, France, 1953

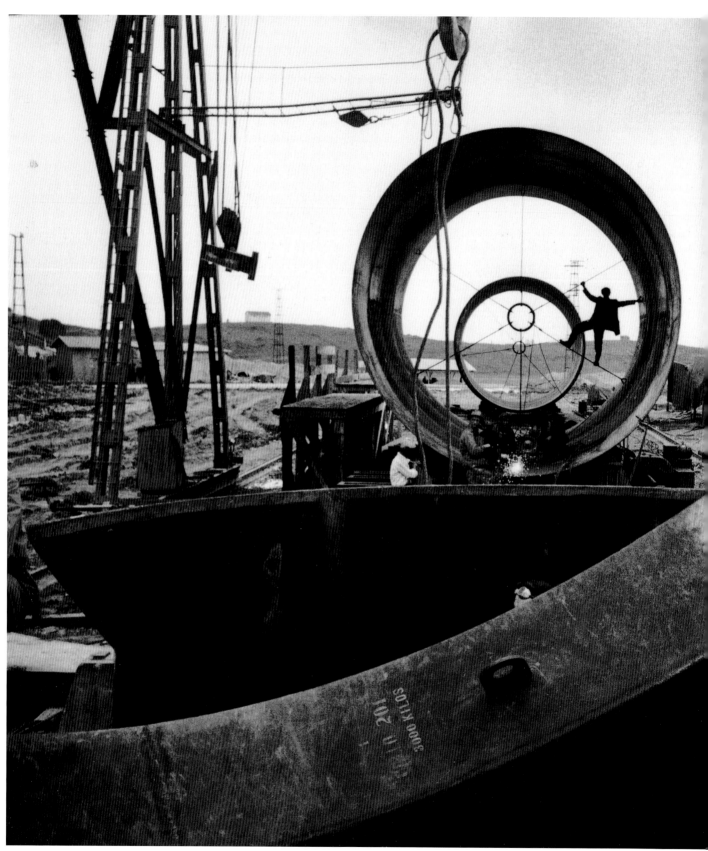

Istanbul, Turkey, 1955

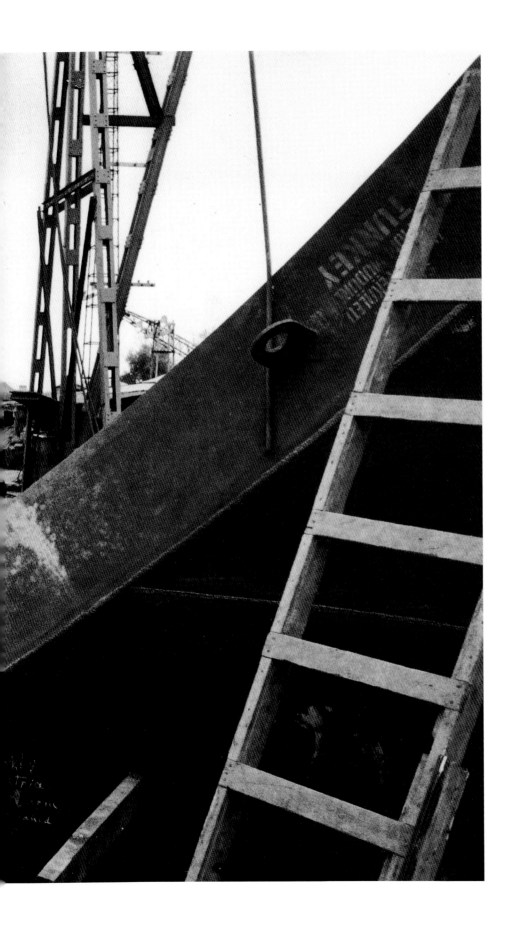

for Asleep

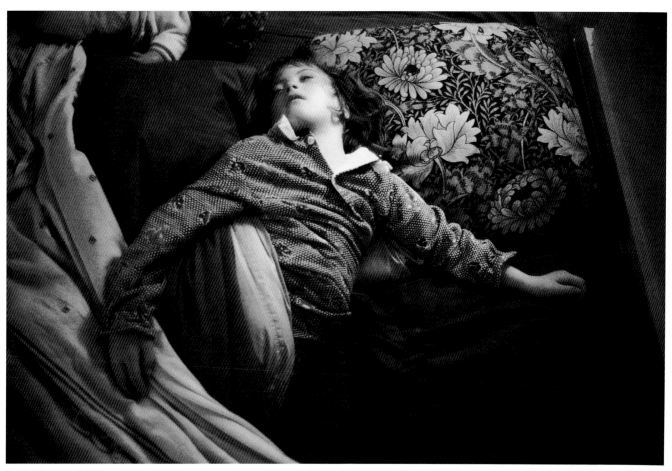

Paris, France, 1990

for Abdomen

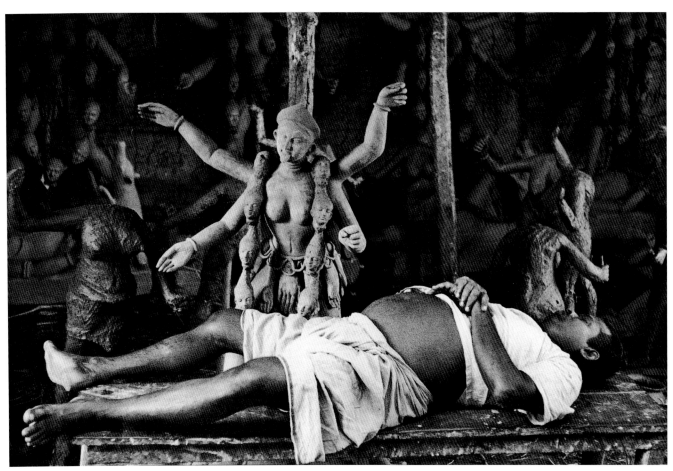

Old Delhi, India, 1956

for Alone

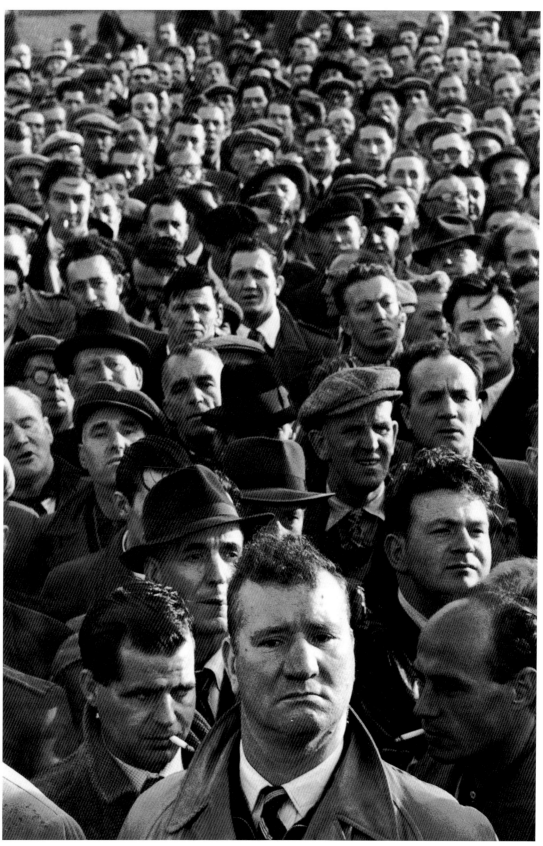

Strike in Liverpool. England, 1954

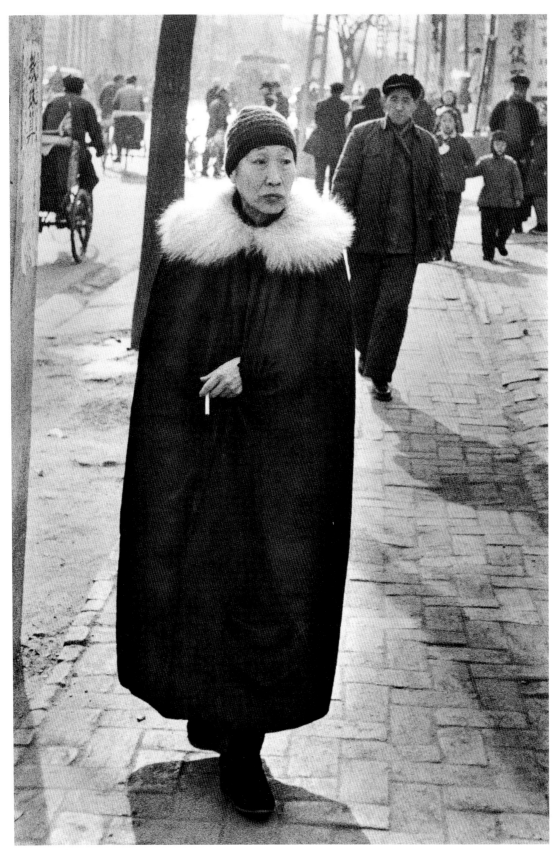

Beijing, China, 1957

B for Books

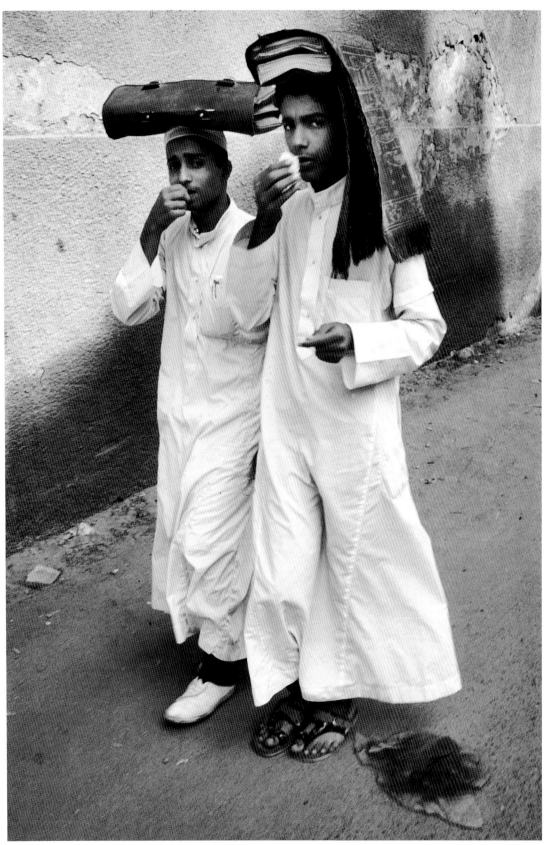

Riyadh, Saudi Arabia, 1974

for Bowler Hat

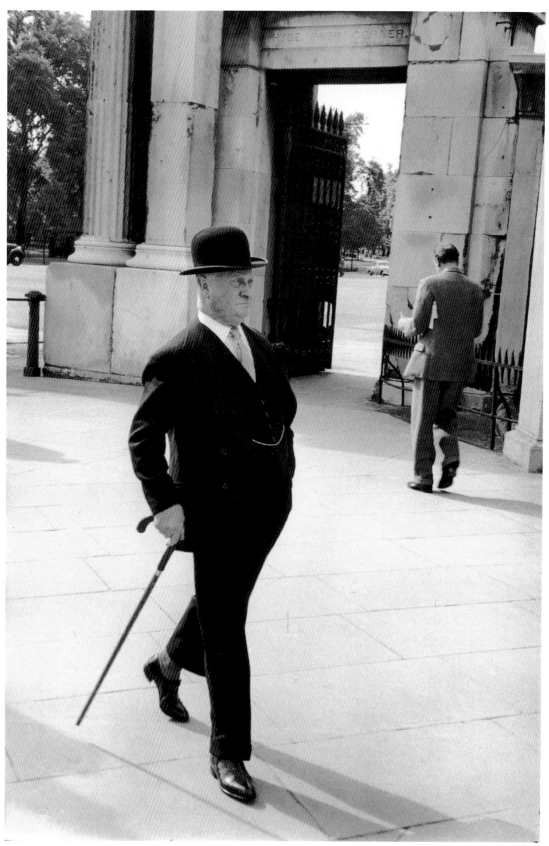

London, England, 1954

for Bottom

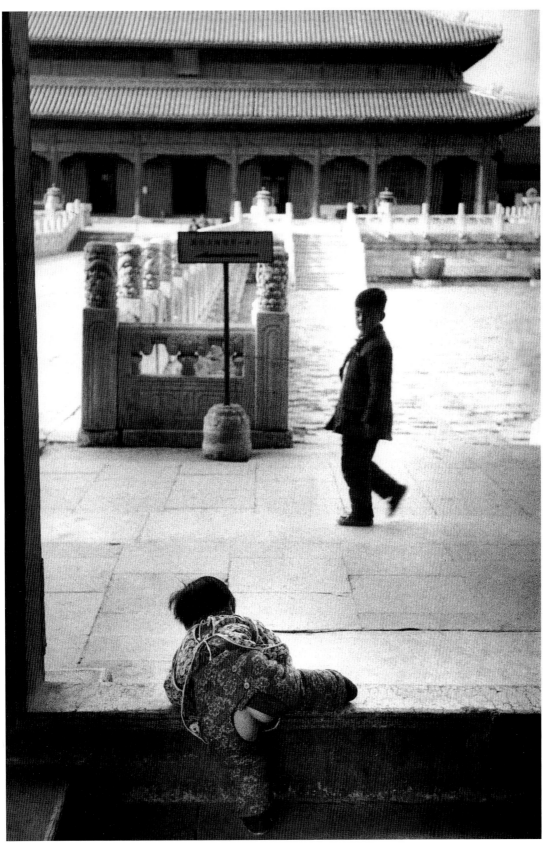

Forbidden City. Beijing, China, 1957

for Boat

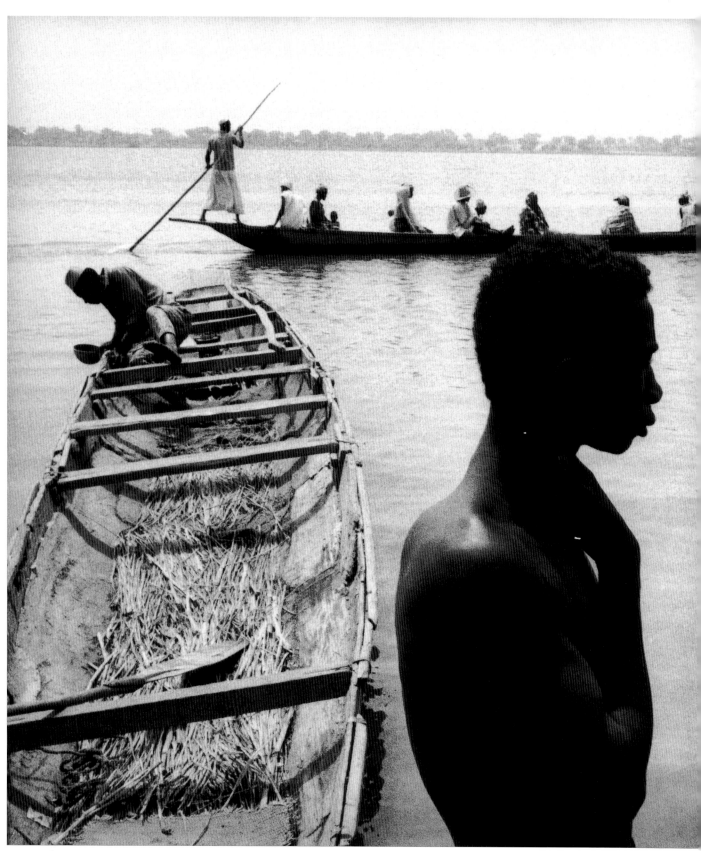

Accra, Ghana, 1960

C for Cameraman

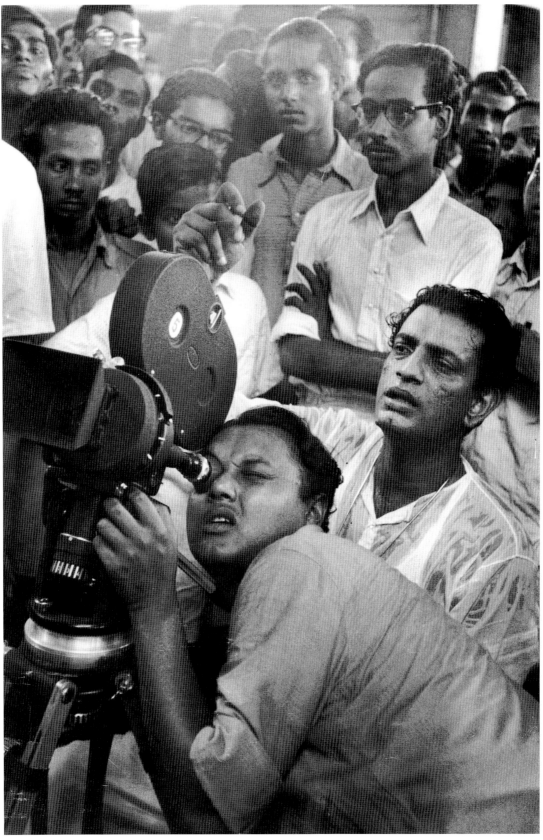

Calcutta, India, 1956

for Couple

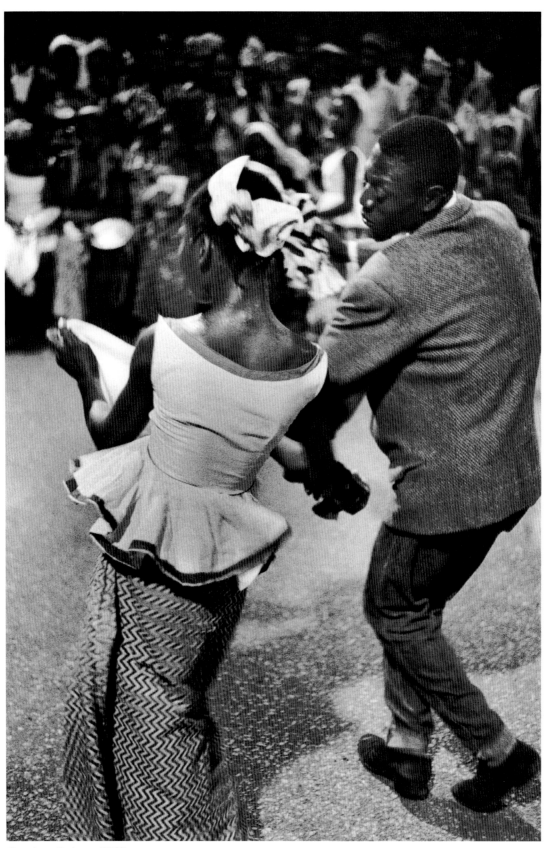

Conakry, Guinea, 1960

for Cheerful

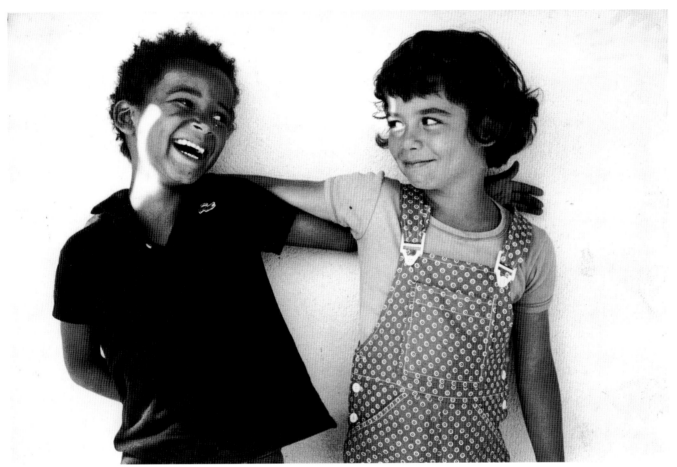

Paris, France, 1974

for Curious

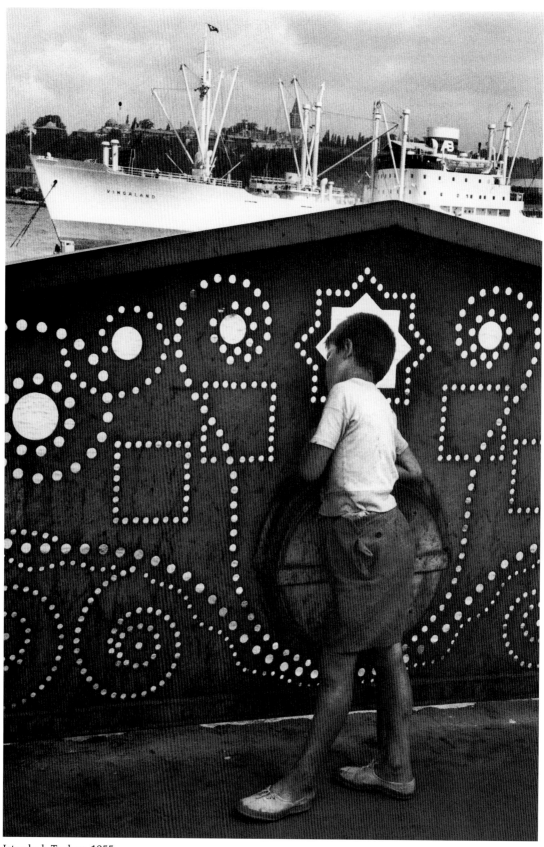

Istanbul, Turkey, 1955

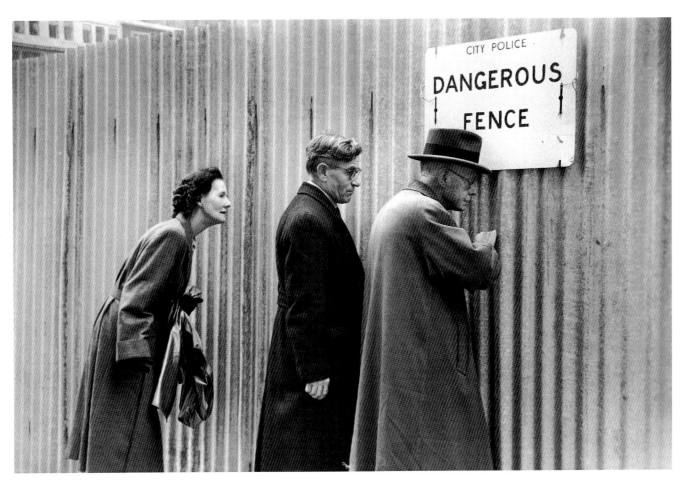

London, England, 1954

D for Dinosaur

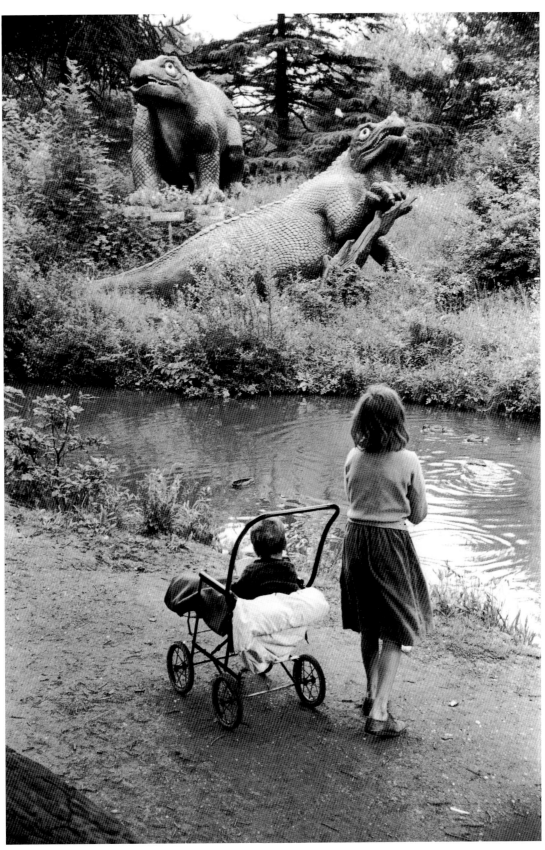

London, England, 1954

for Donkey

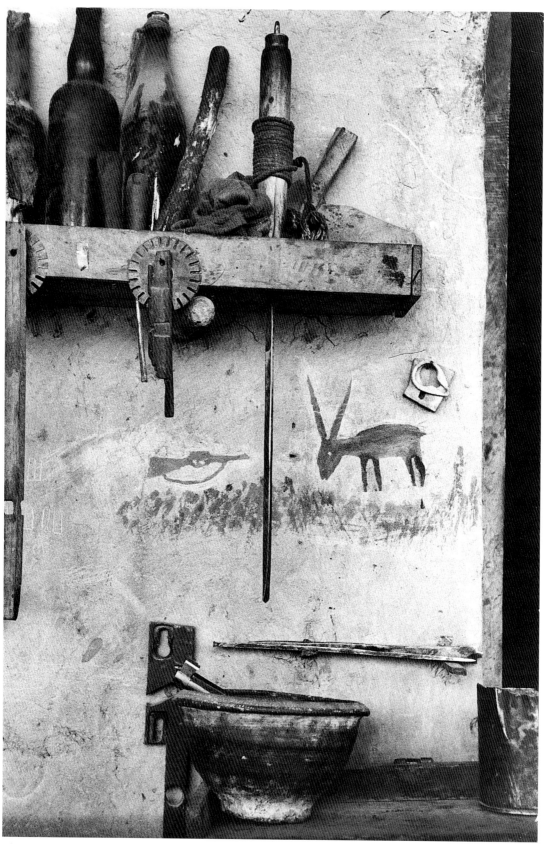

Khyber Pass, Afghanistan, 1955

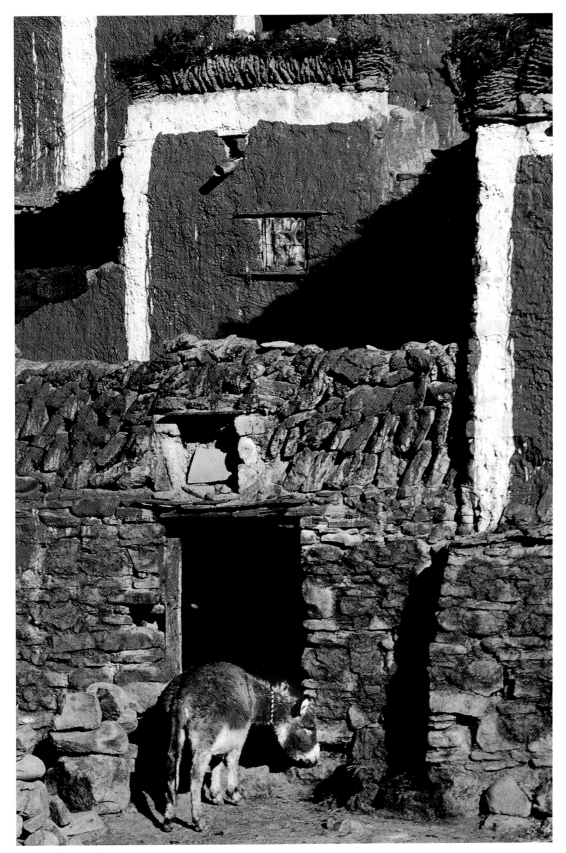

Lhasa, Tibet, 1985

for Dream

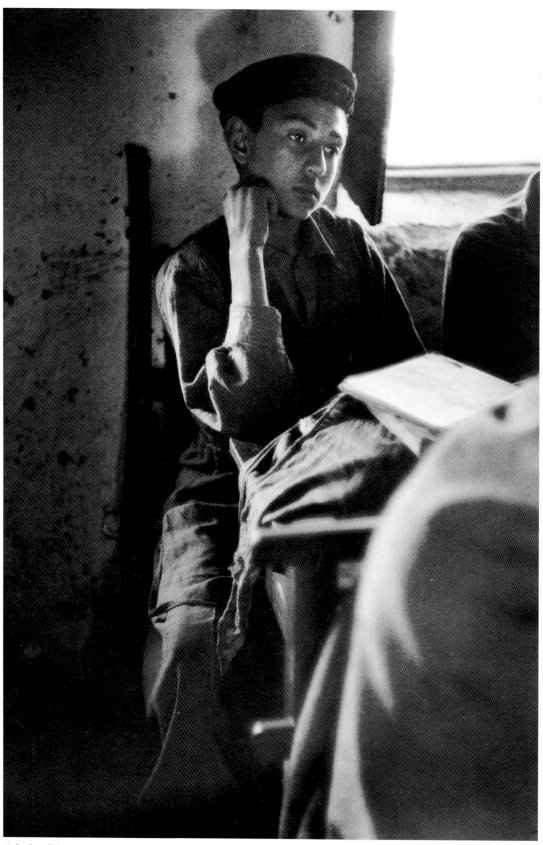

Kabul, Afghanistan, 1955

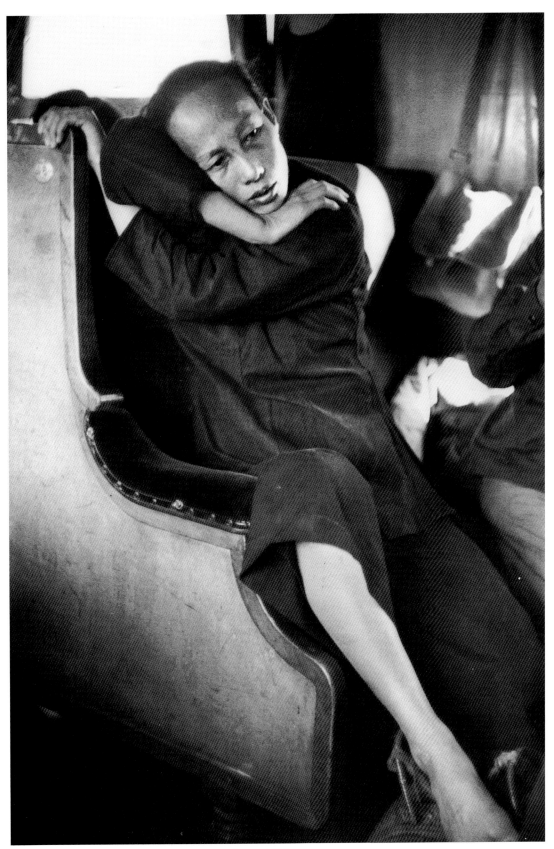

On the train from Guangzhou to Beijing. China, 1957

E for Elephants

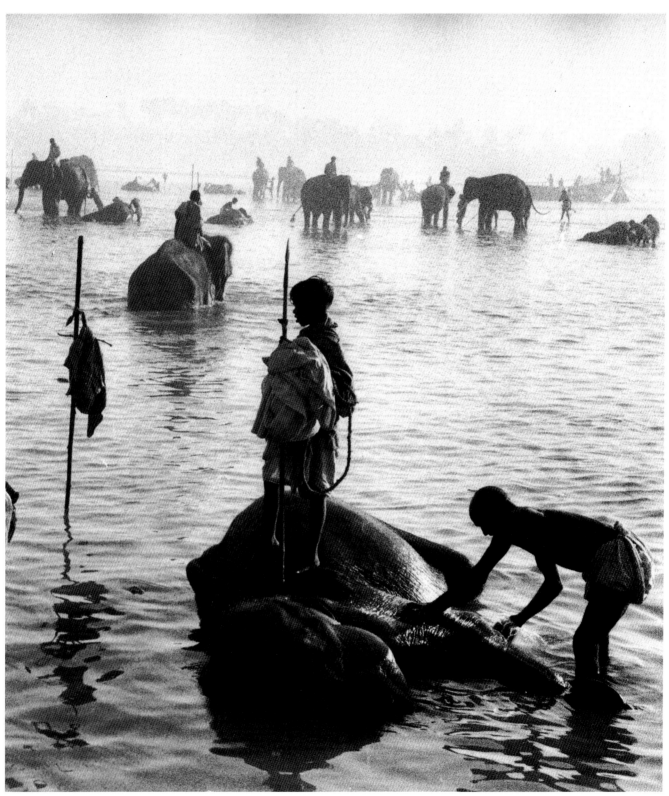

Benares, India, 1956

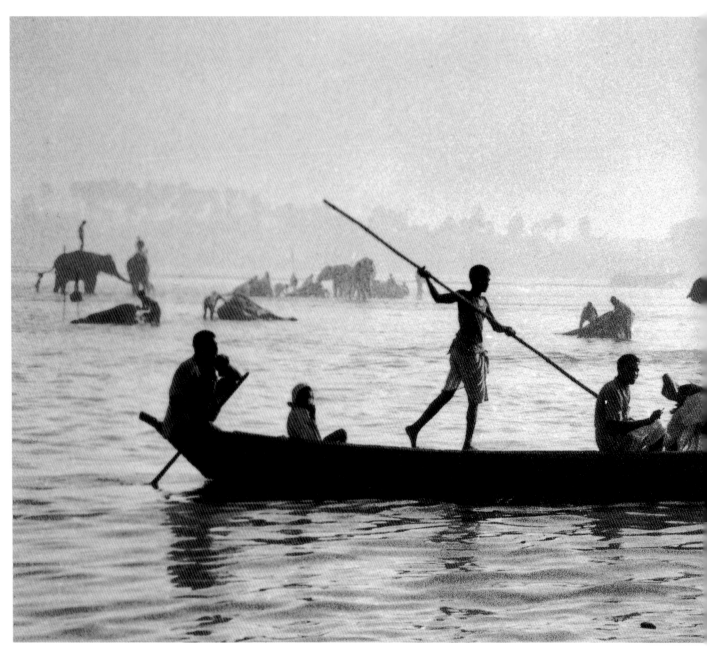

Benares, India, 1956

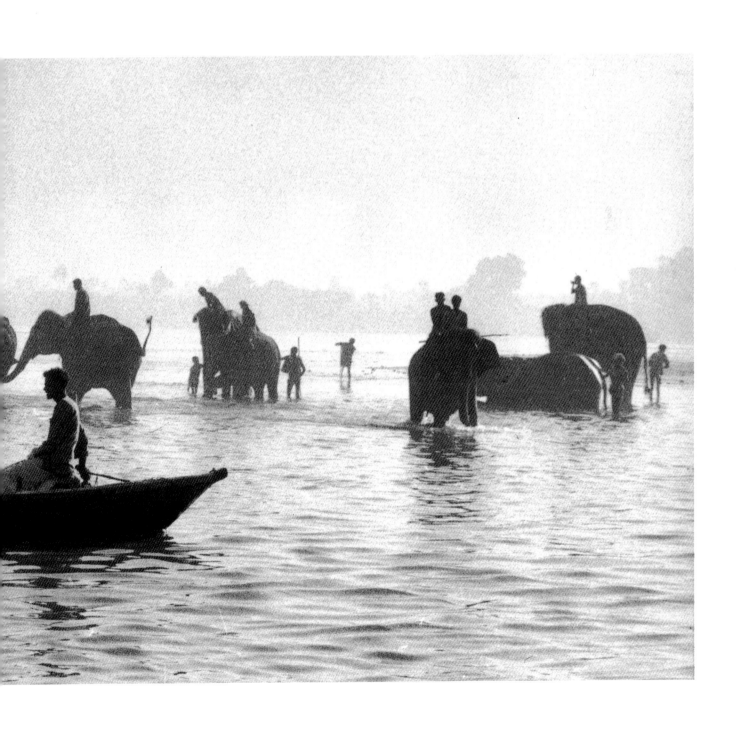

for Eat

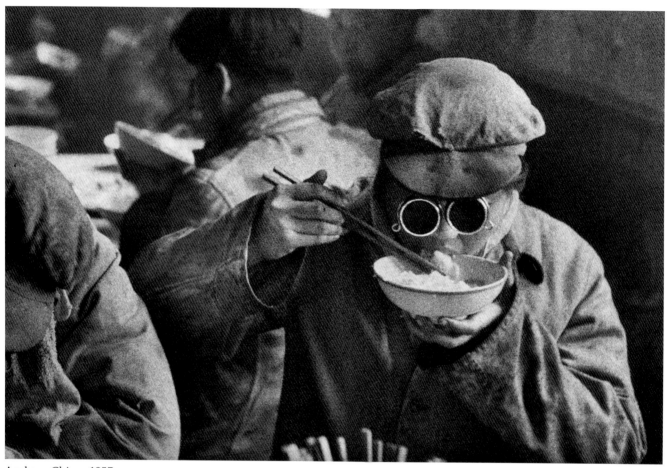

Anshan, China, 1957

for Eyes

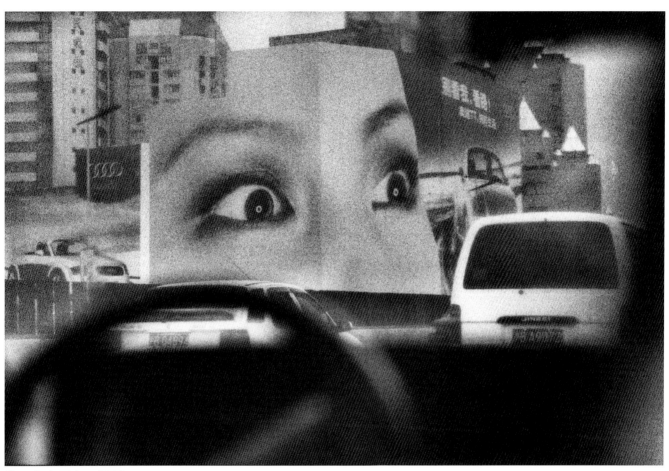

Shanghai, China, 2002

for Evening

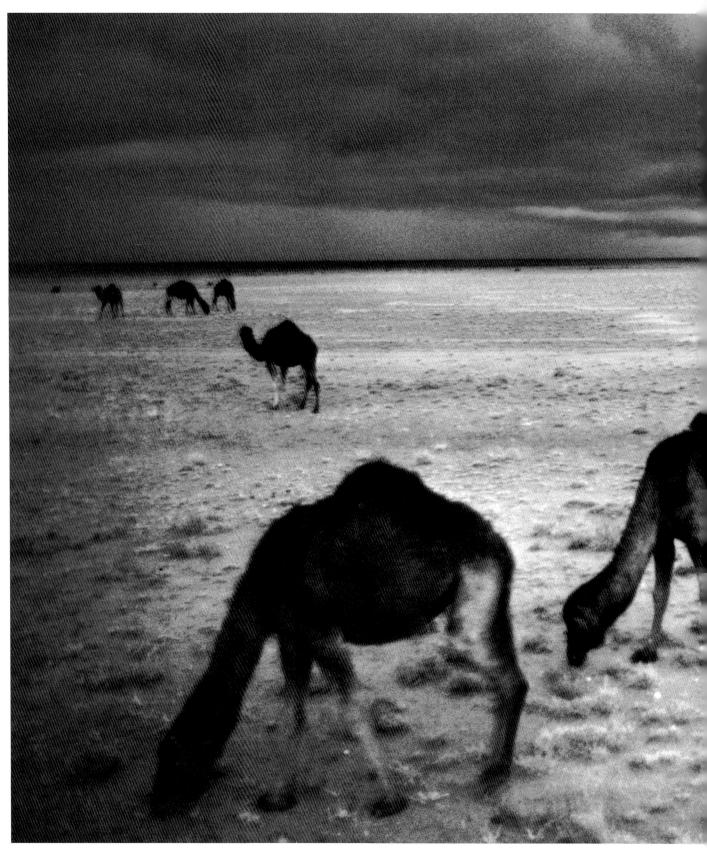

Desert in South Algeria, Algeria, 1960

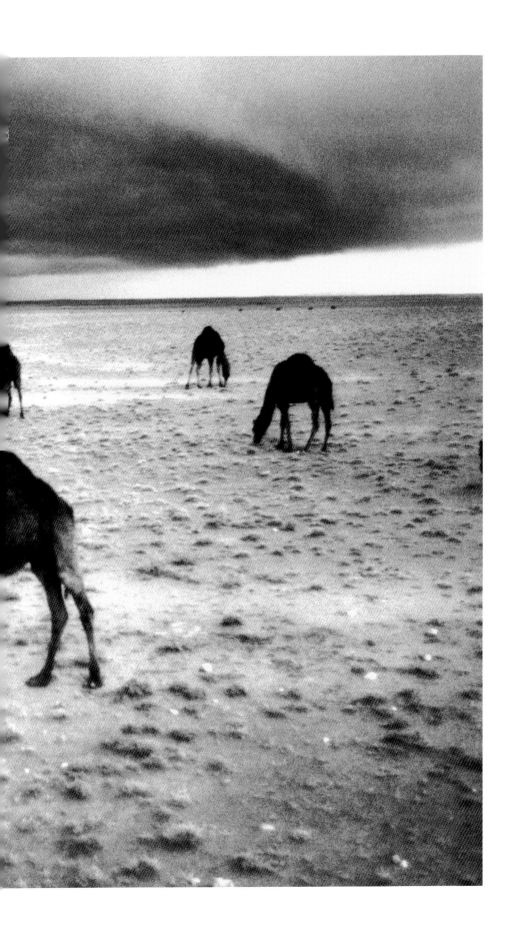

F for Flight

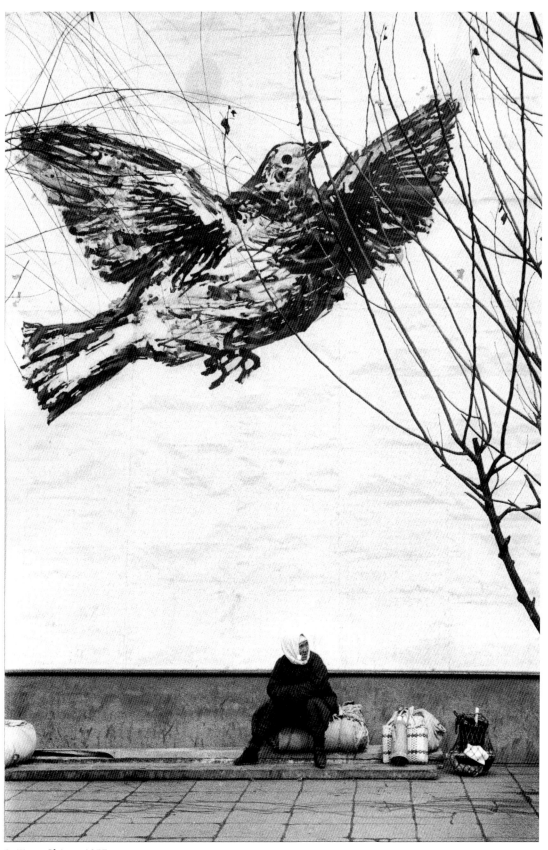

Beijing, China, 1957

for Factory

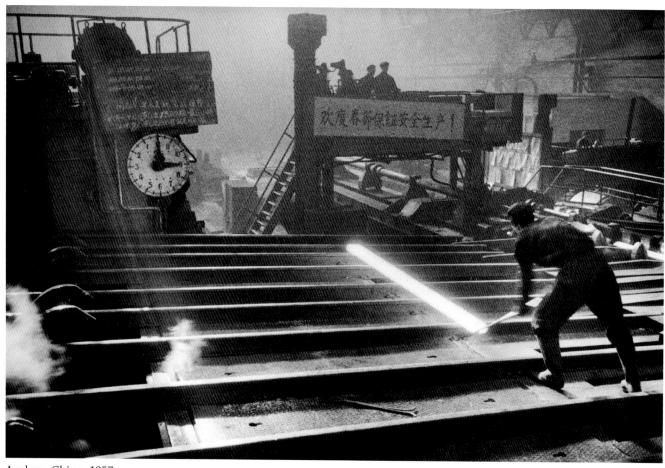

Anshan, China, 1957

for Fatigue

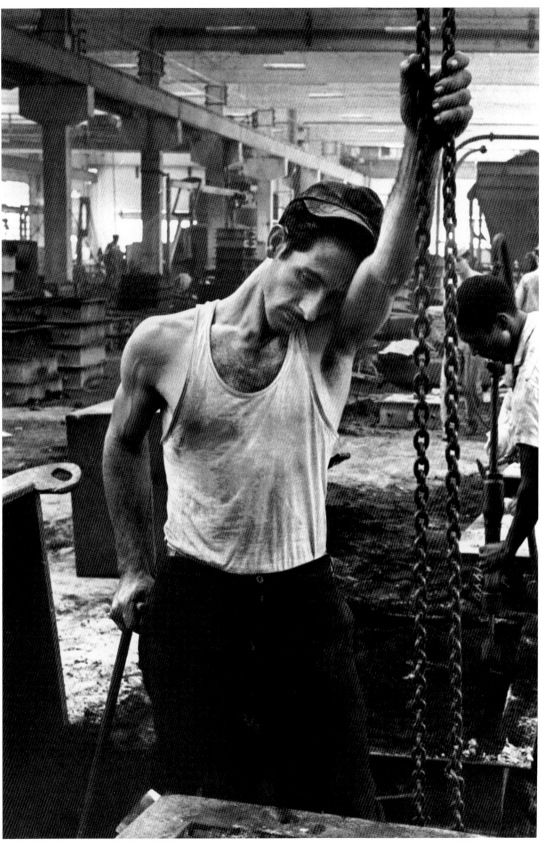

Havana, Cuba, 1963

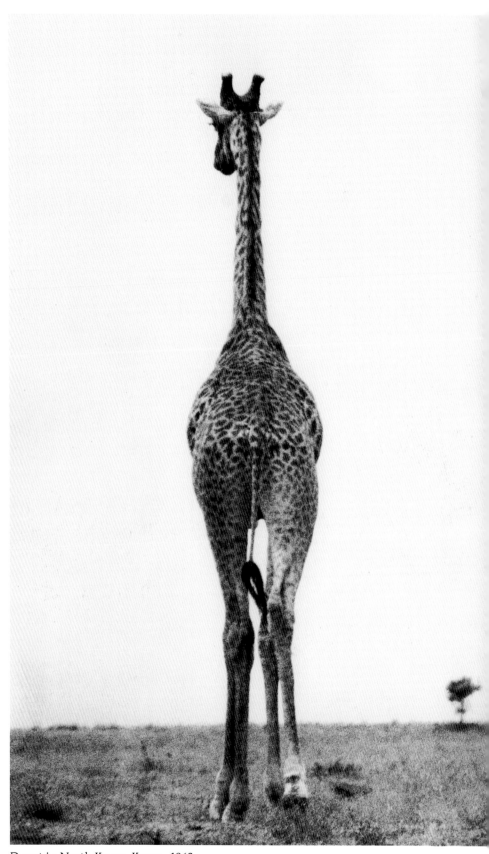

Desert in North Kenya, Kenya, 1963

G for Giraffe

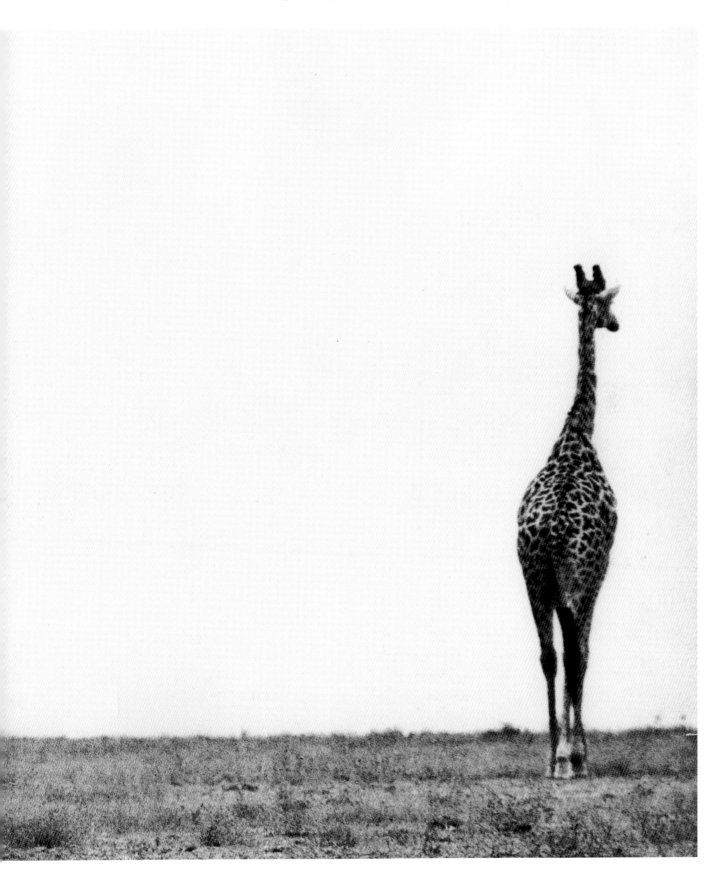

for Game

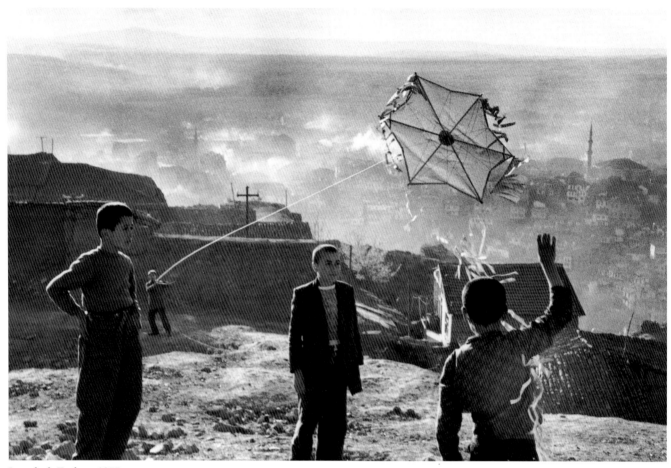

Istanbul, Turkey, 1955

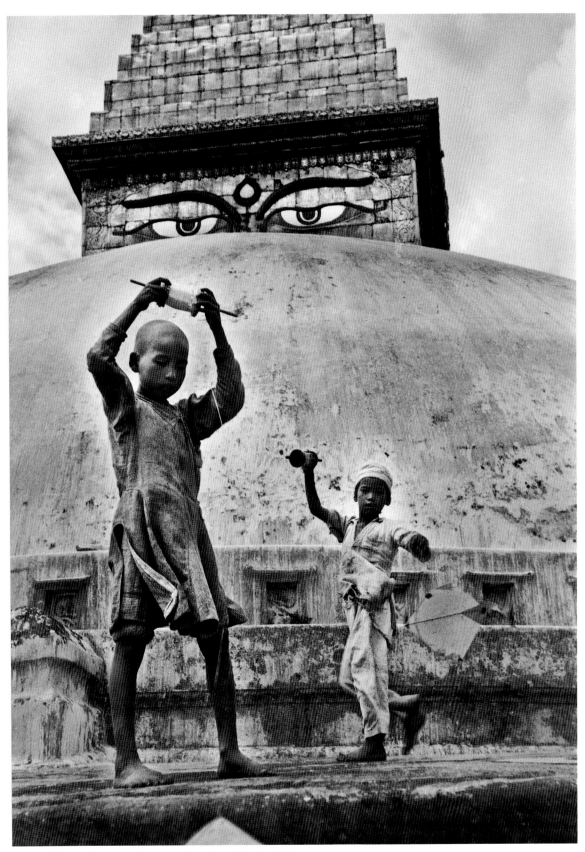

Swayambhunath stupa, Kathmandu valley. Nepal, 1956

for Grace

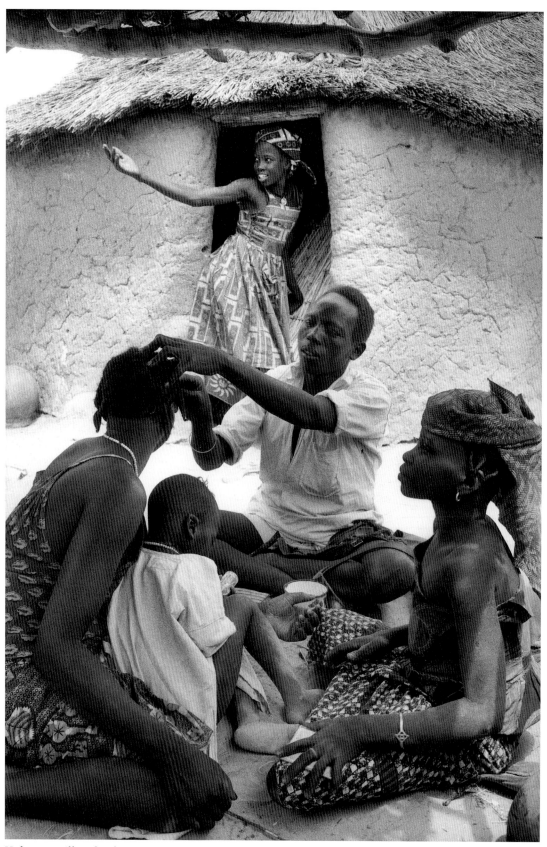

Unknown village by the river Niger, Niger, 1963

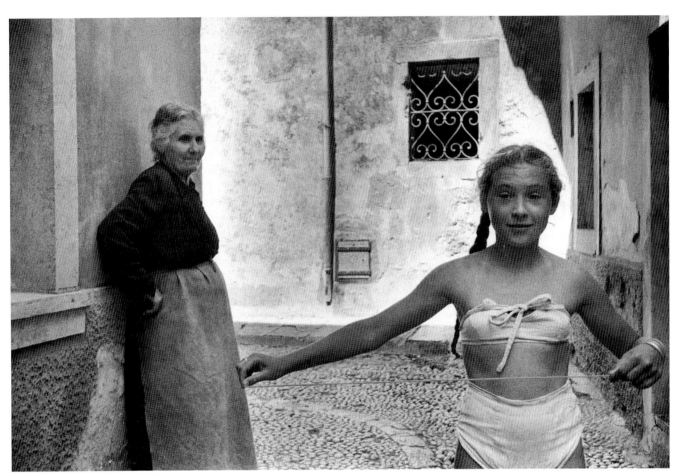

Dubrovnik, Yugoslavia, 1954

for Group

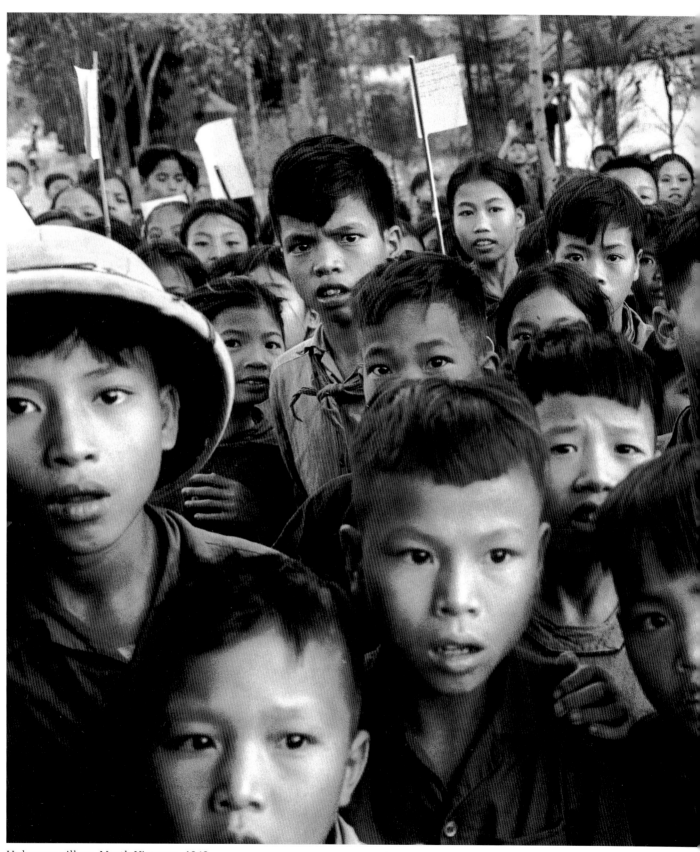

Unknown village, North Vietnam, 1969

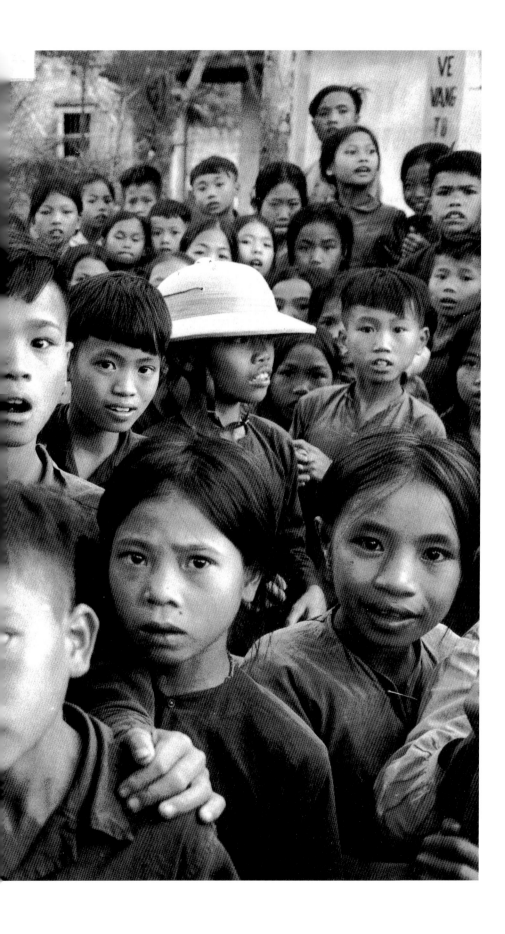

H for Hands

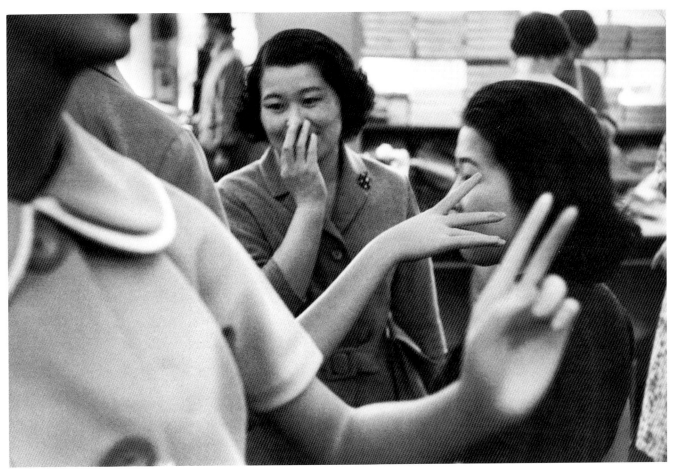

Tokyo, Japan, 1958

for Hammock

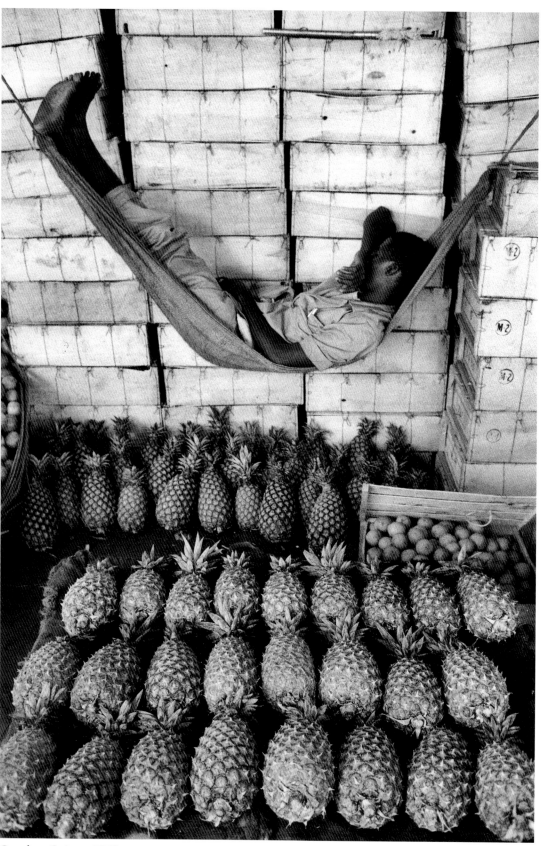

Conakry, Guinea, 1960

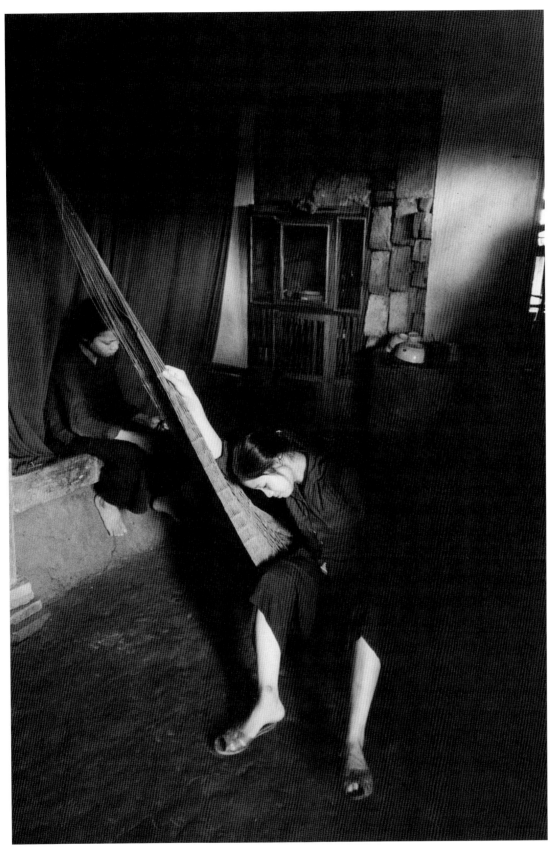

Hanoi, North Vietnam, 1969

for Herbs

Touraine, France, 2000

I for Imitate

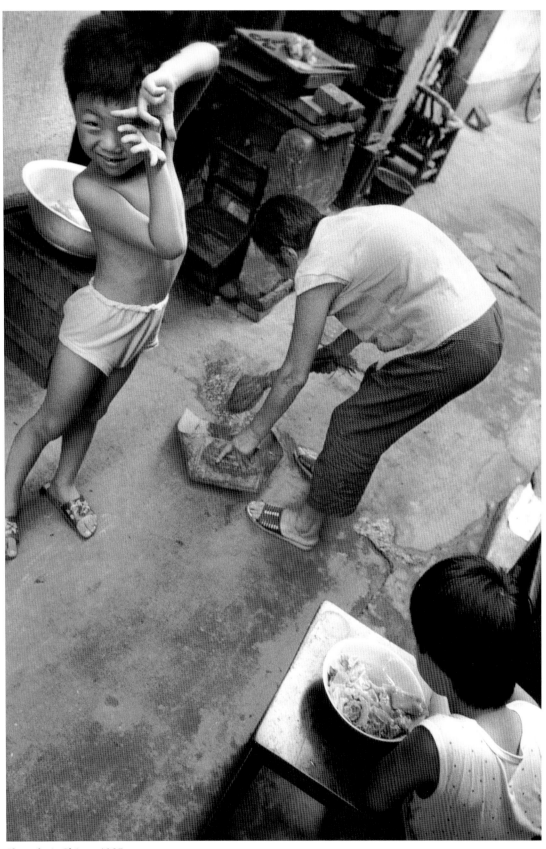

Shanghai, China, 1995

for Intense

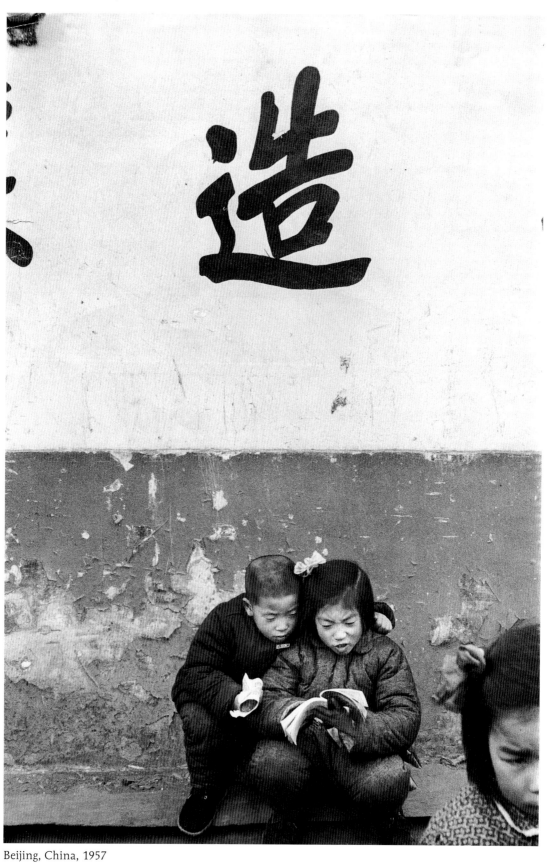

Beijing, China, 1957

for Ice

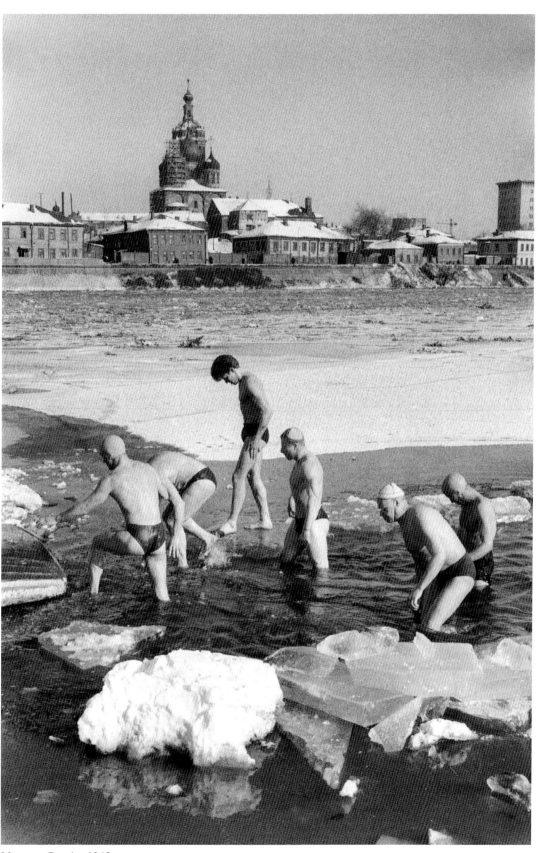

Moscow, Russia, 1960

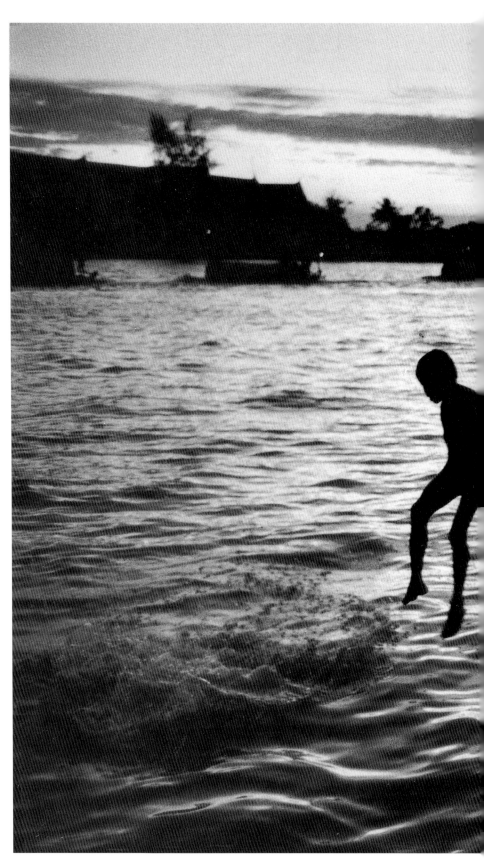

Bangkok, Thailand, 1969

J for Jump

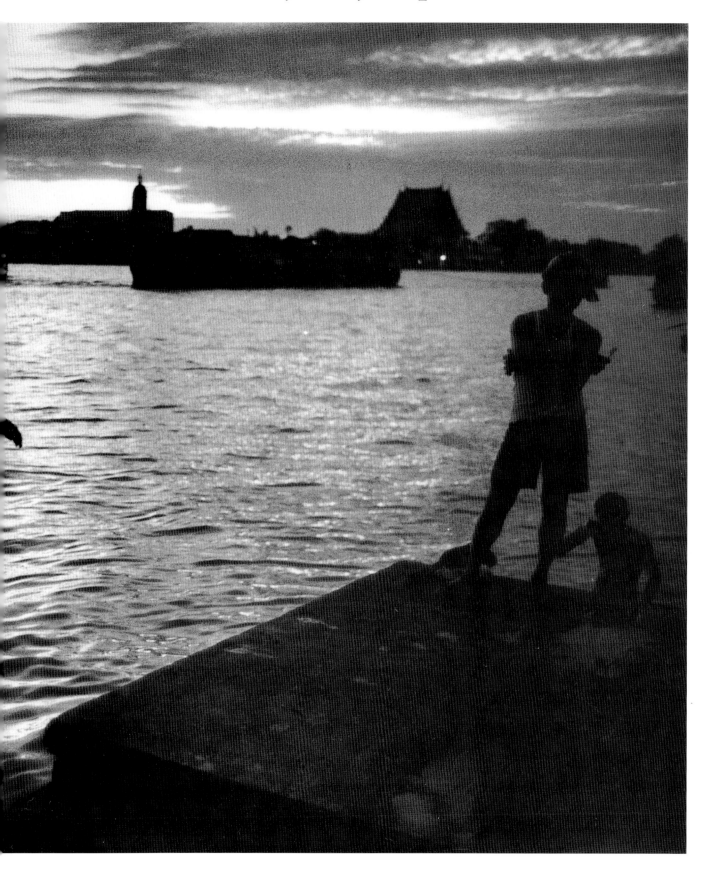

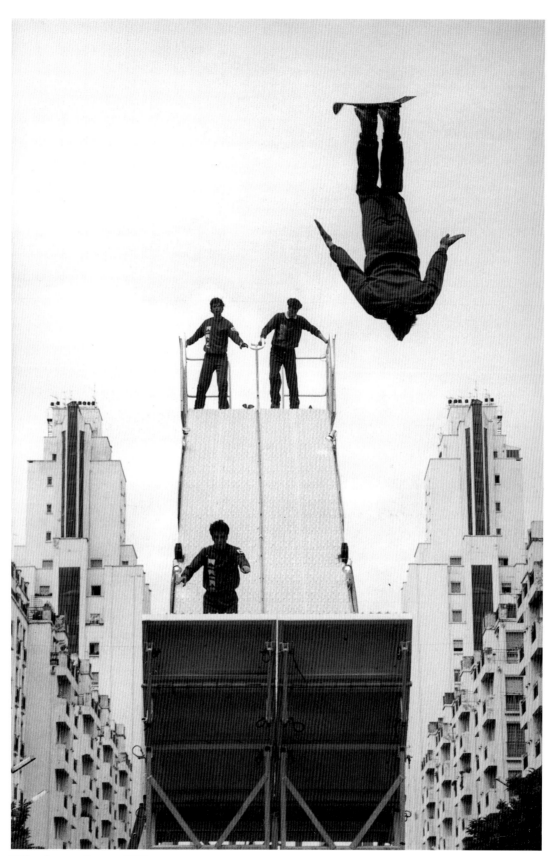

Villeurbanne, France, 1984

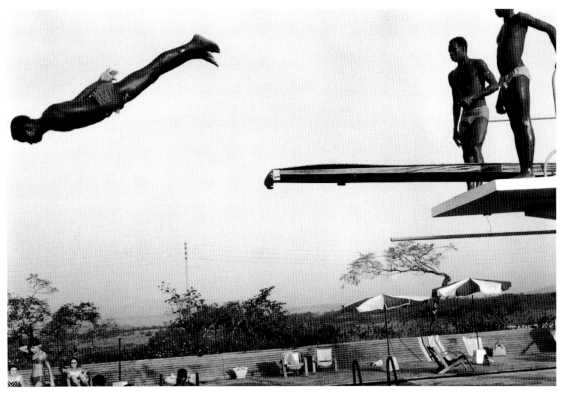

Conakry, Guinea, 1960

Shanghai, China, 2002

for Joy

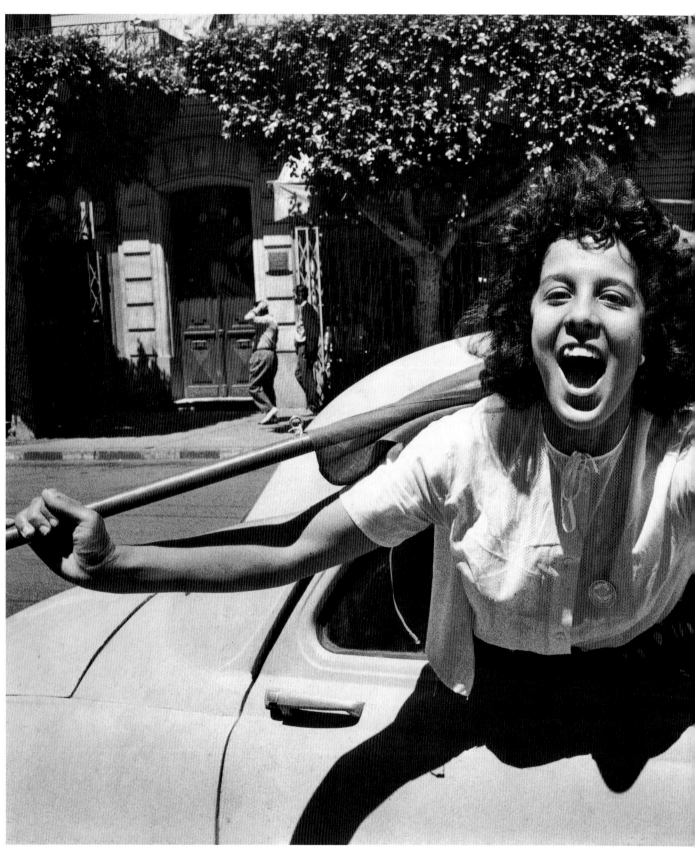

Algiers, Algeria. July 1962, Independence Day.

K for Kayak

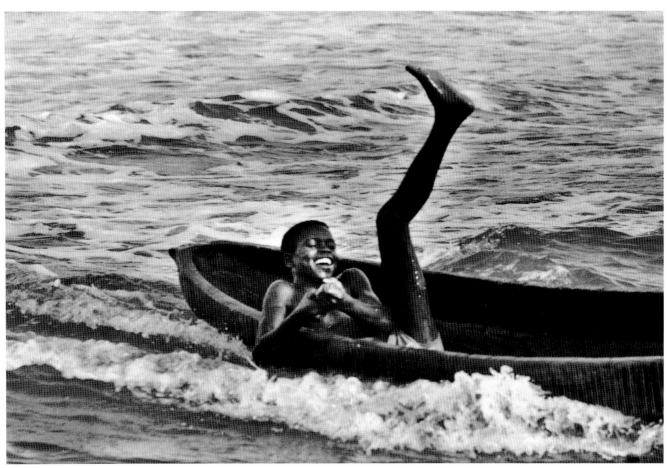

Accra, Ghana, 1960

for Keel

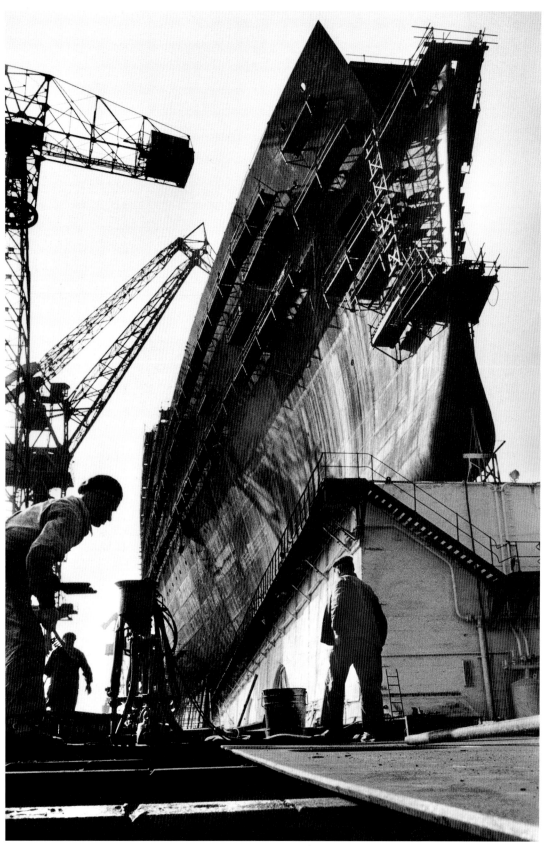

Saint-Nazaire, France, 1959

for Kimono

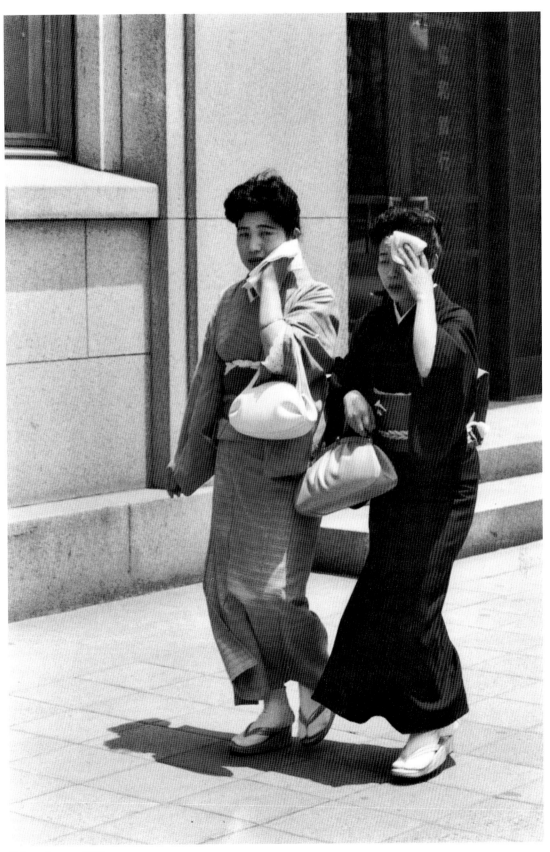

Tokyo, Japan, 1958

for Kiss

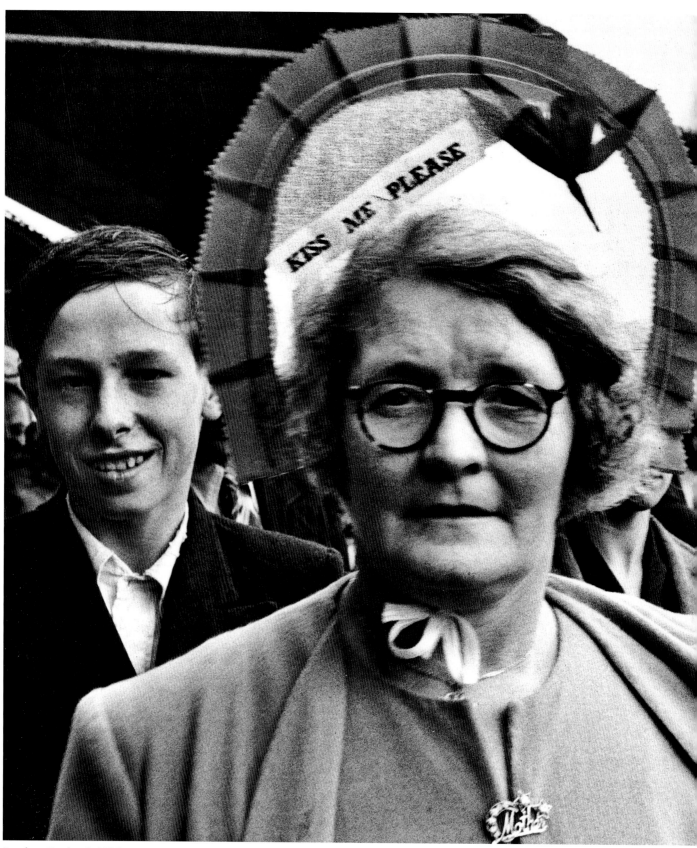

London, England, 1954

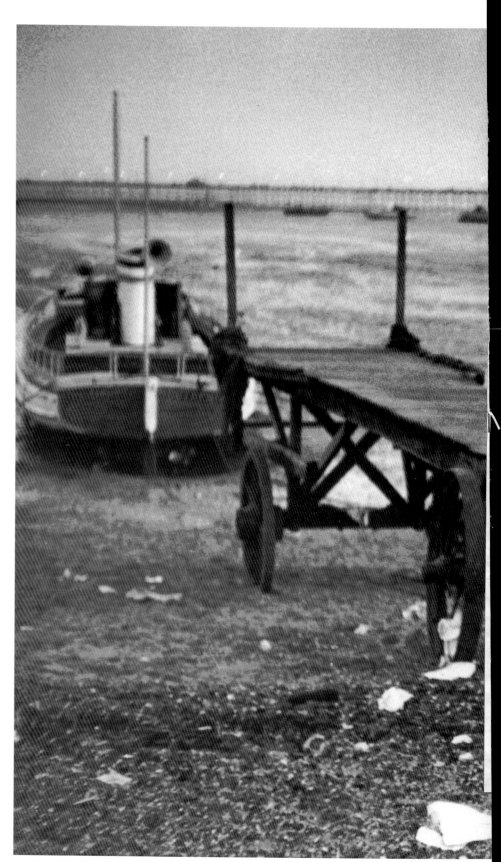

Southend, England, 1955

L for Lovers

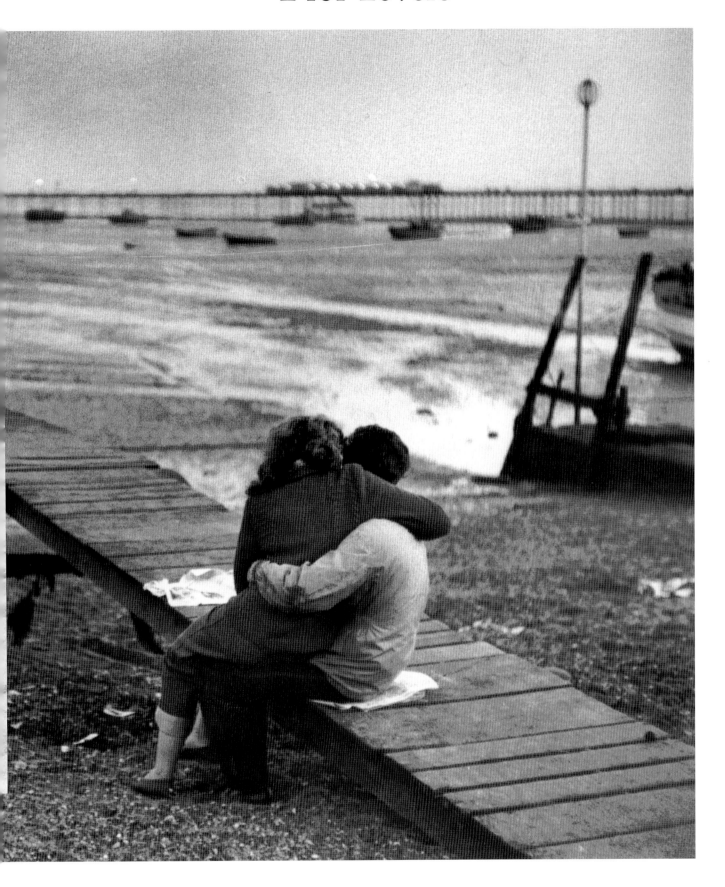

for Lazy

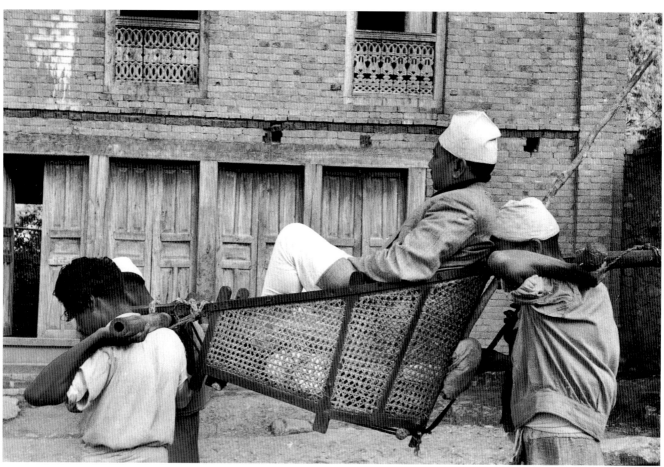

Kathmandu, Nepal, 1956

for Ladder

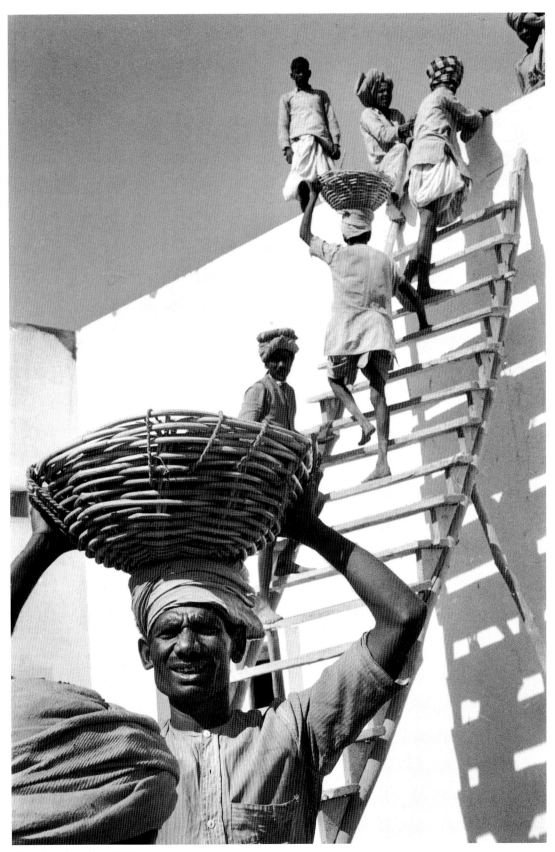

Chandigarh, India, 1956

M for Mother

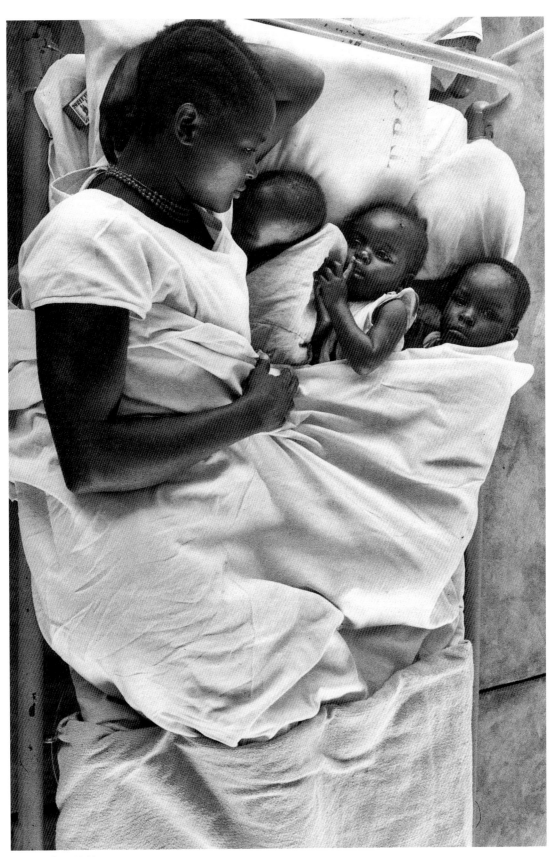

Tanganyka, 1961

for Market

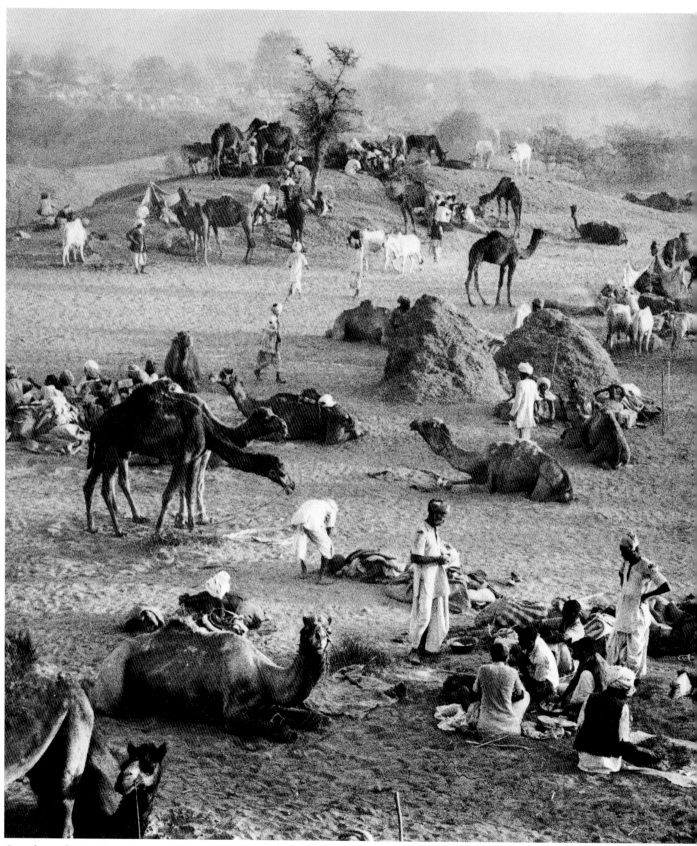

Camels market in Nagor. India, 1956

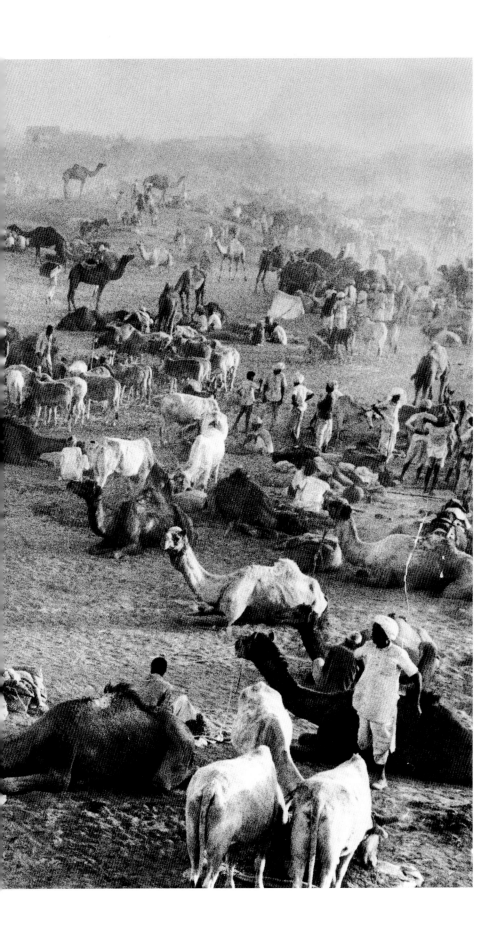

for Miner

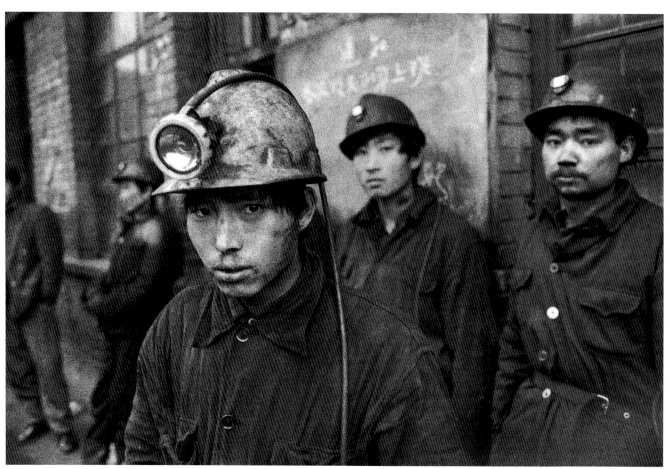

Taiyuan, China, 1995

for Mess

Beijing, China, 1992

for Mercy

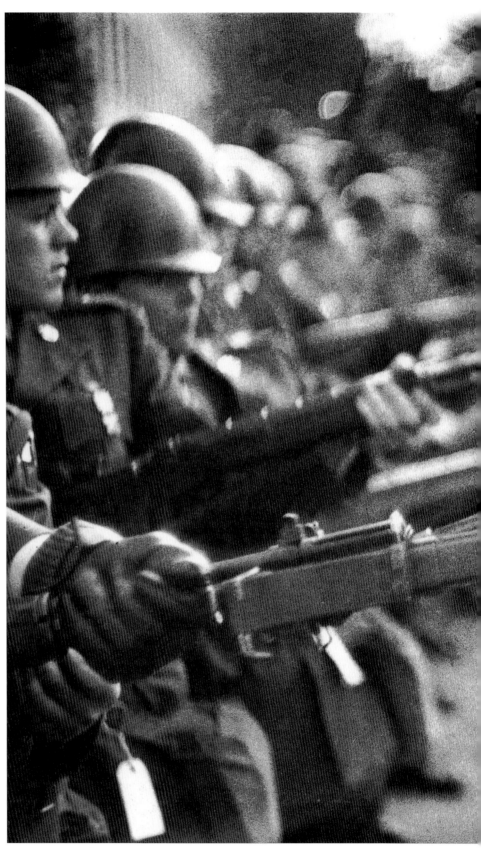

Protest against the war in Vietnam. Washington, USA, 1967

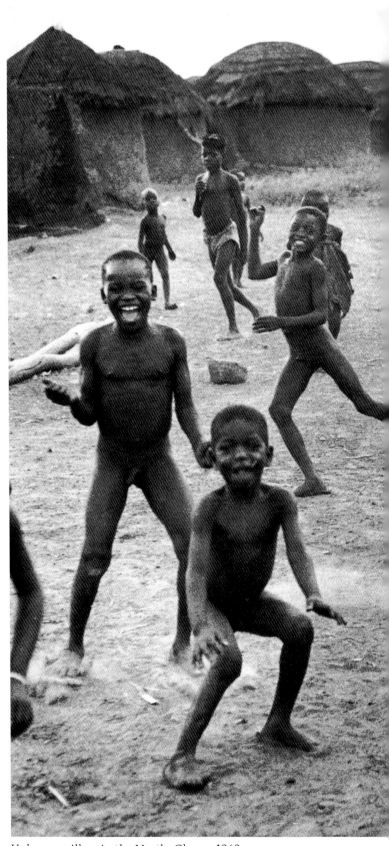

Unknown village in the North, Ghana, 1960

N for Naked

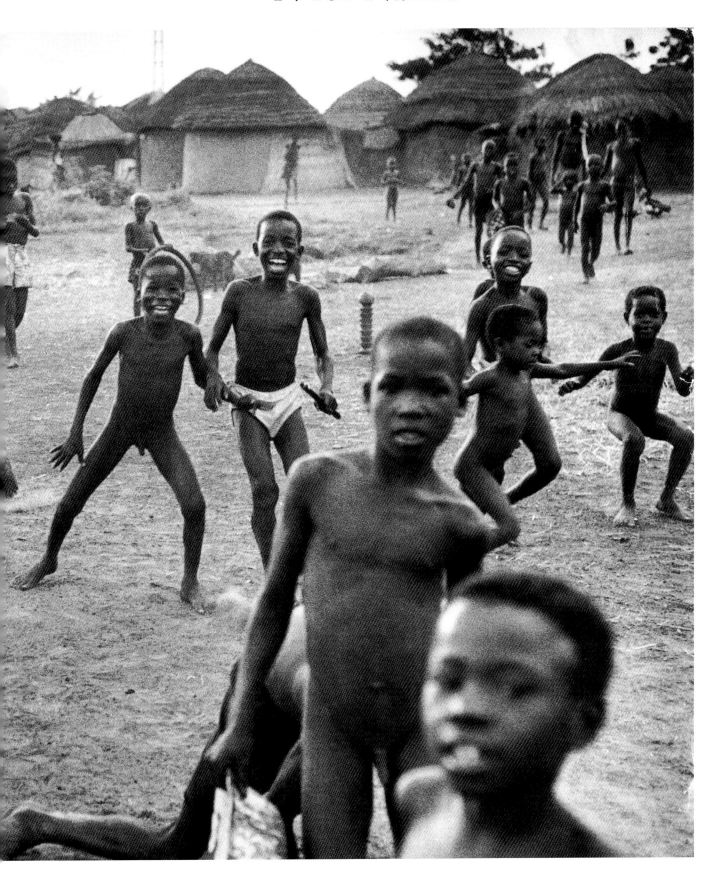

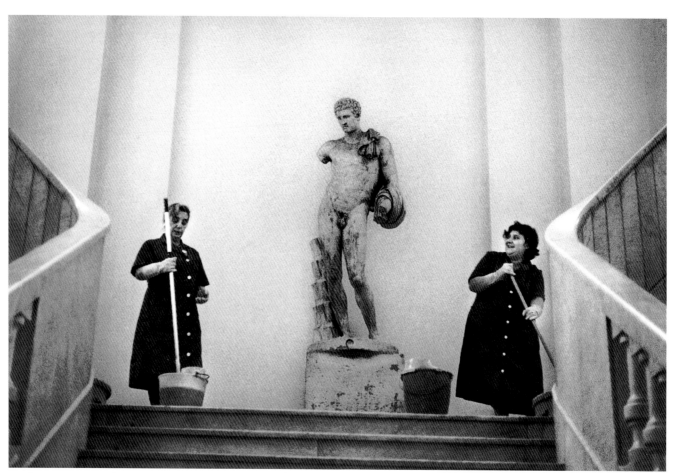

Prado Museum. Madrid, Spain, 1988

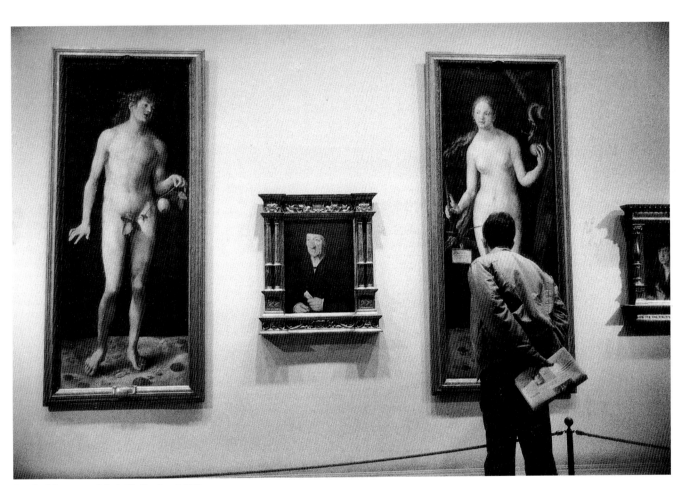

Prado Museum. Madrid, Spain, 1988

for Nap

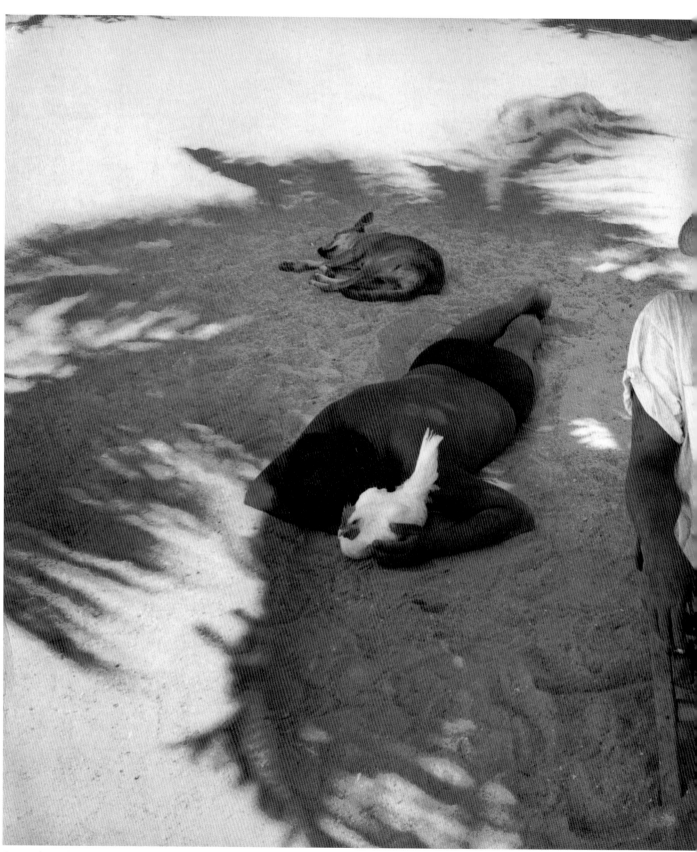

Accapulco, Mexico, 1969

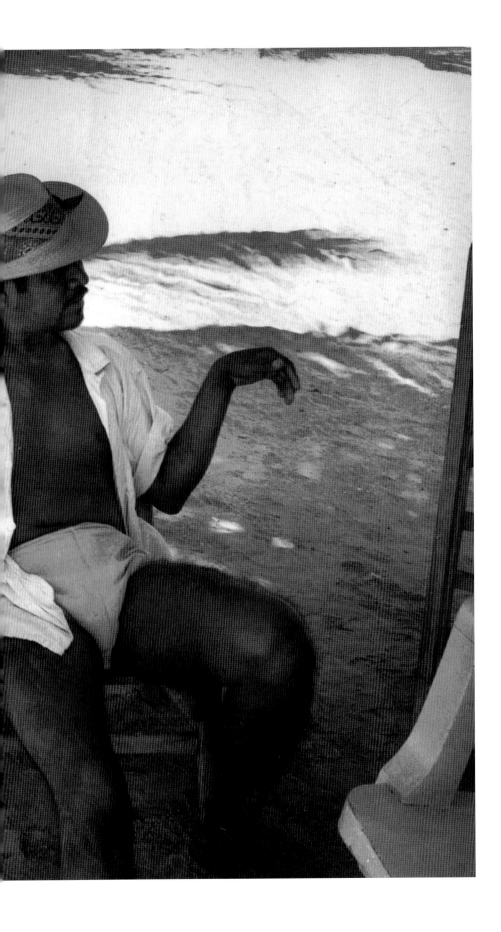

O for Oar

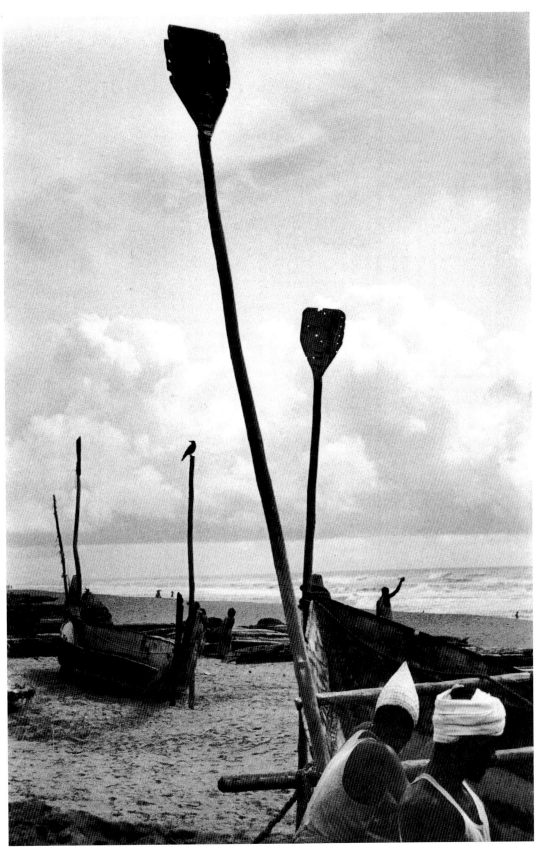

North-east coast, India, 1956

for Oilfield

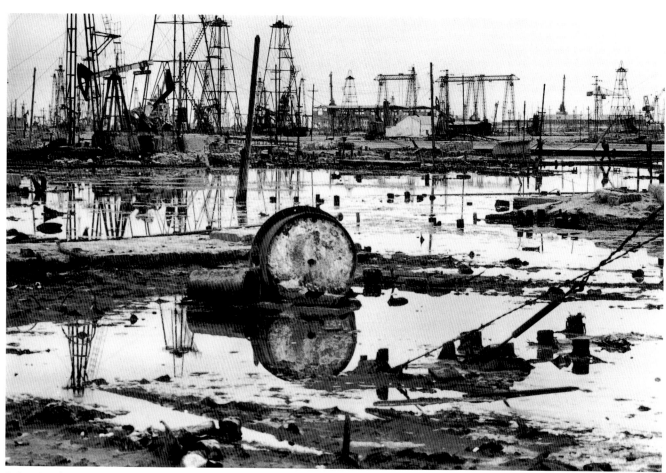

Baku, Azerbaijan, 1998

for Old

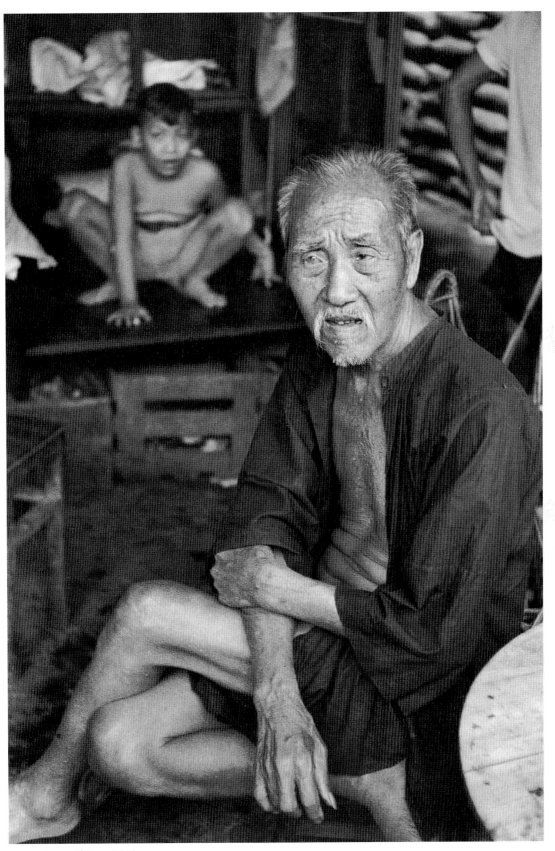

Hong Kong, China, 1956

for Oxygen

Moscow, Russia, 1961

P for Push

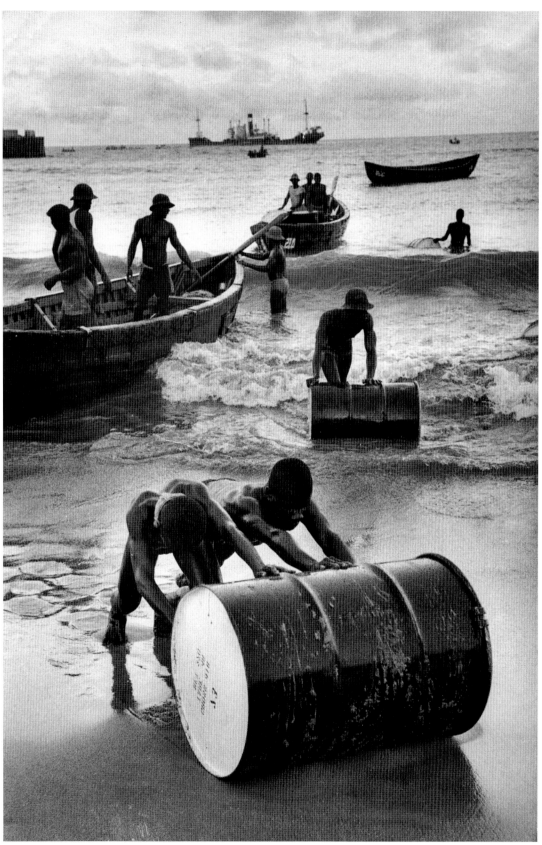

Accra, Ghana, 1960

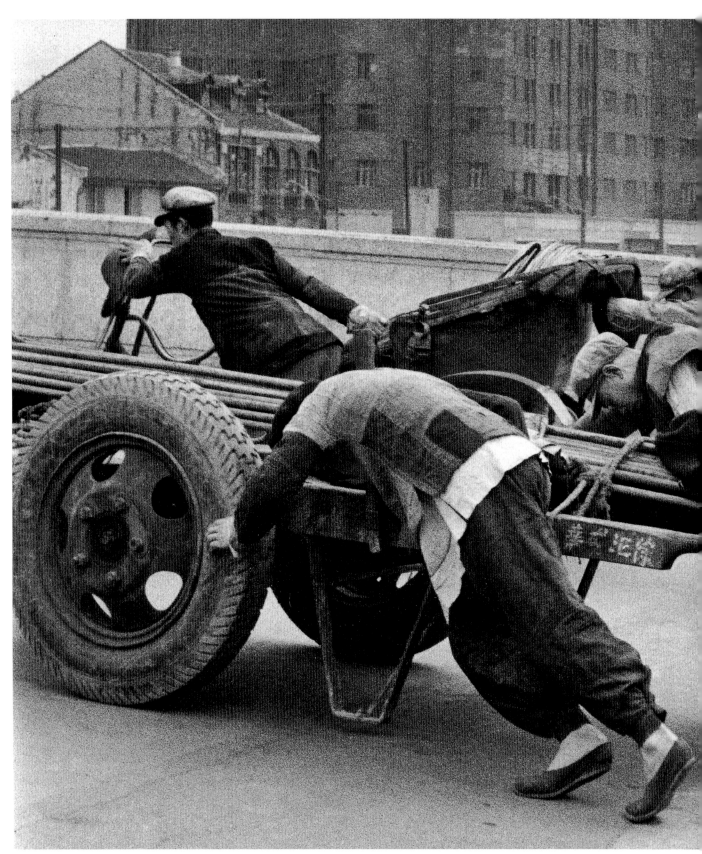

Shanghai, China, 1957

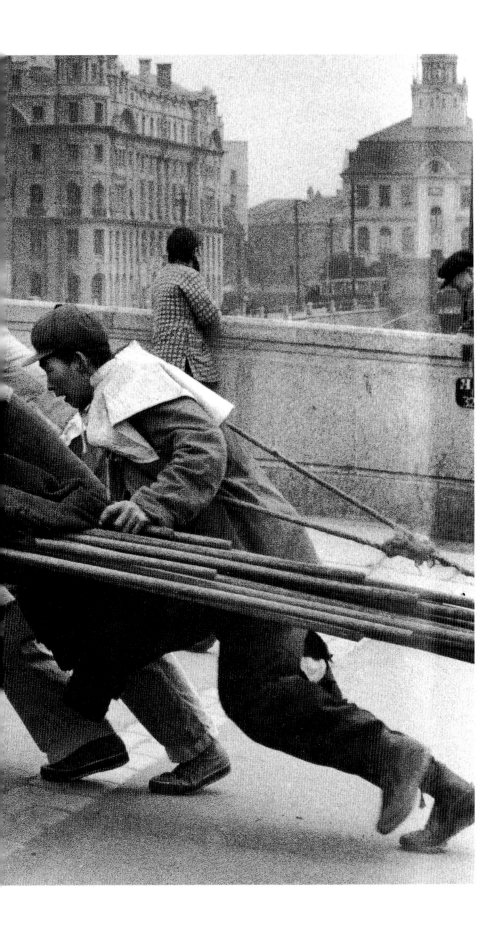

for Pond

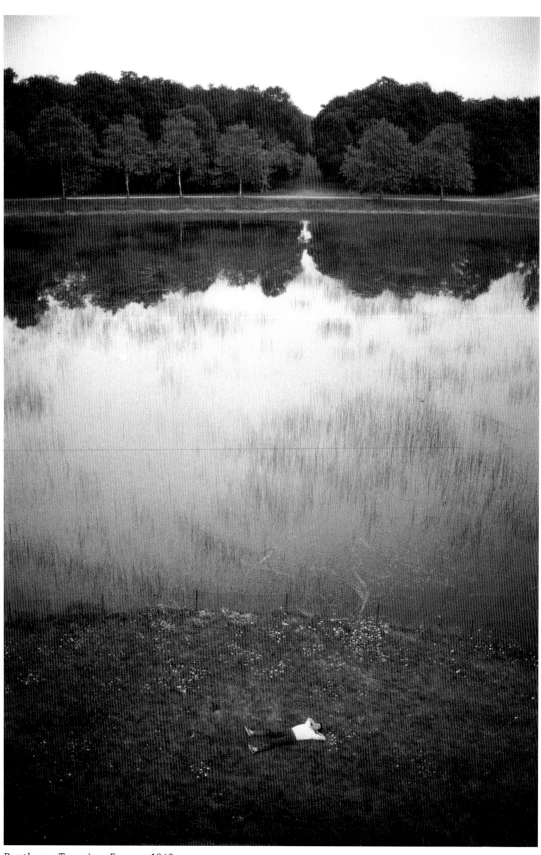

Pontlevoy, Touraine, France, 1963

for Peacock

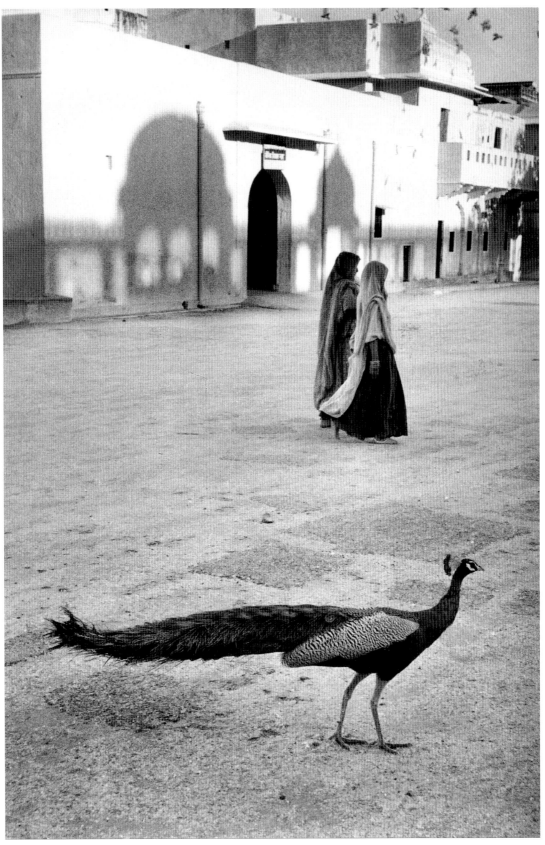

Jaipur, India, 1956

Q for Quarrel

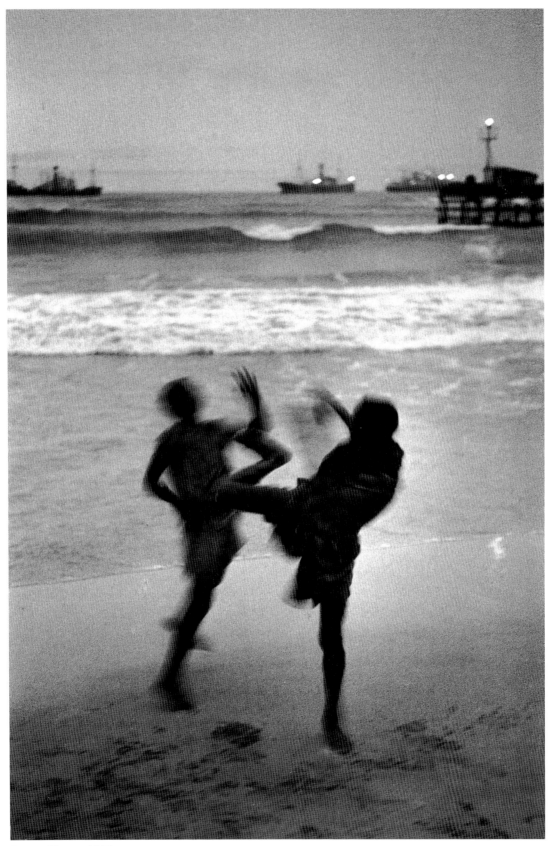

Accra, Ghana, 1960

for Quicken

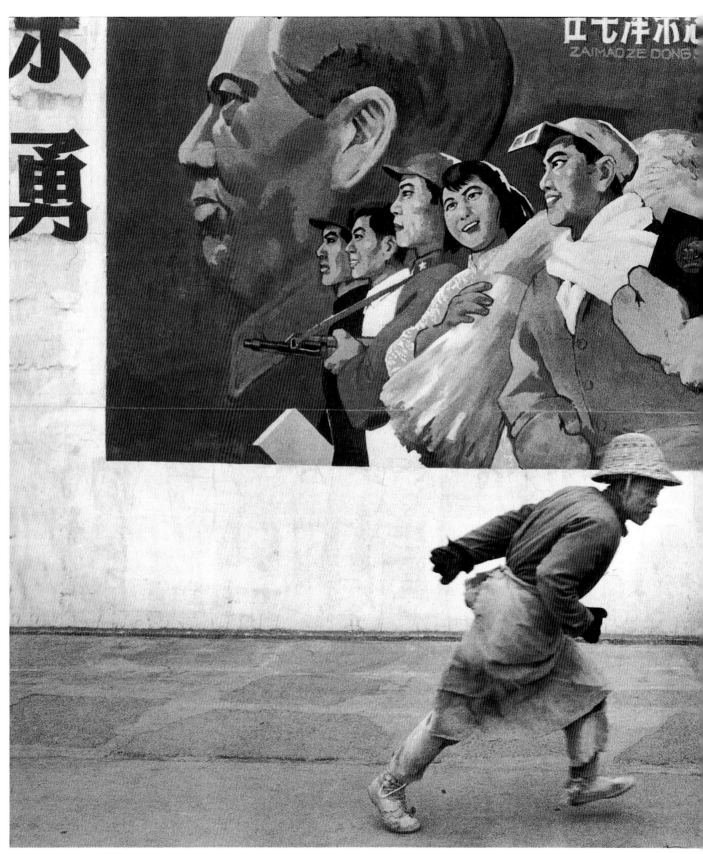

Shanghai, China, 1965

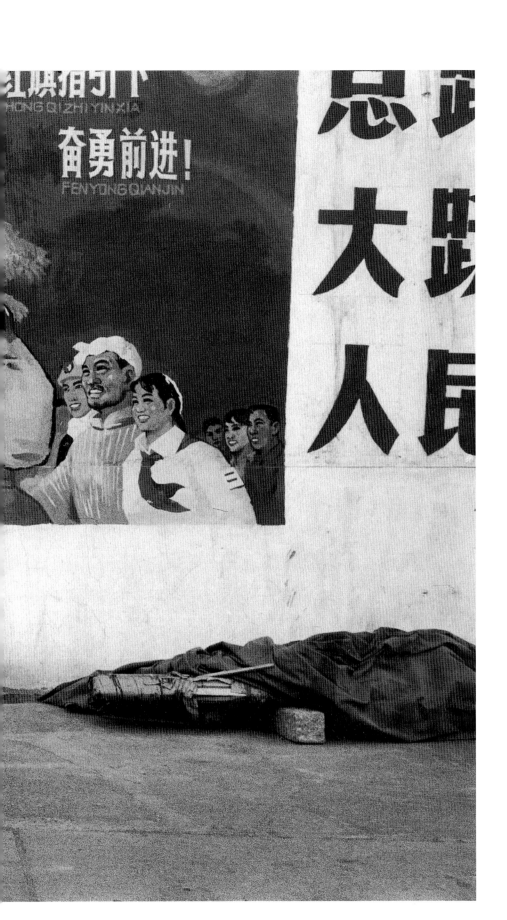

for Quay

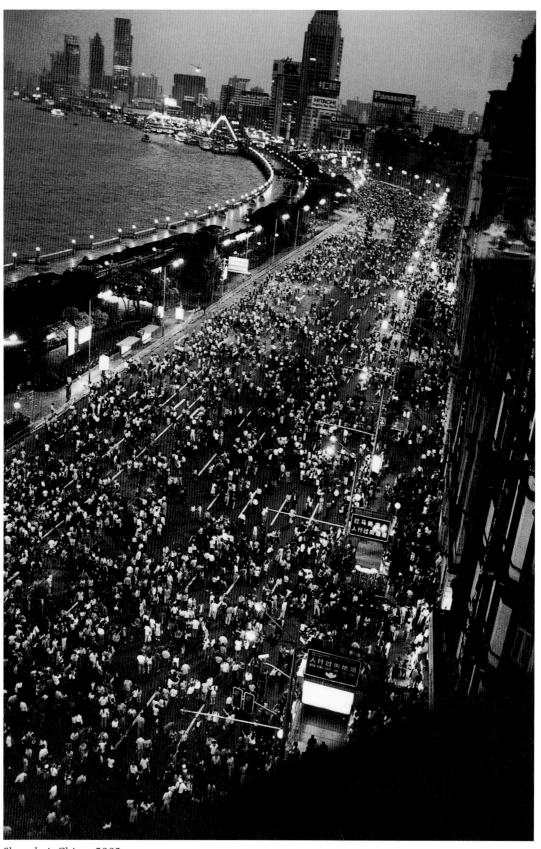

Shanghai, China, 2002

for Quilt

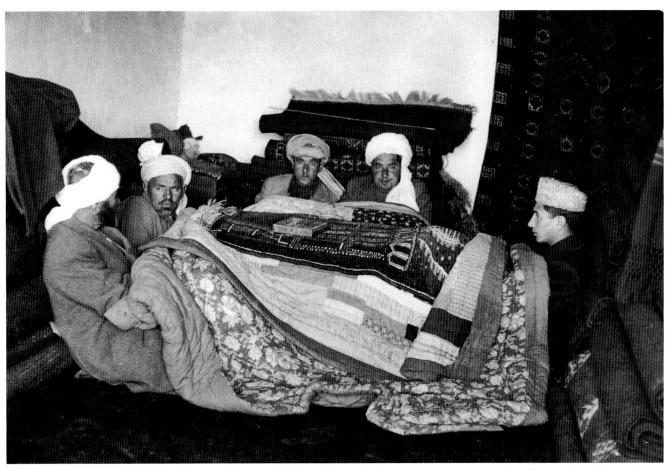

Khyber Pass, Afghanistan, 1955

Cappadocia, Turkey, 1955

R for Rock

for Rabbit

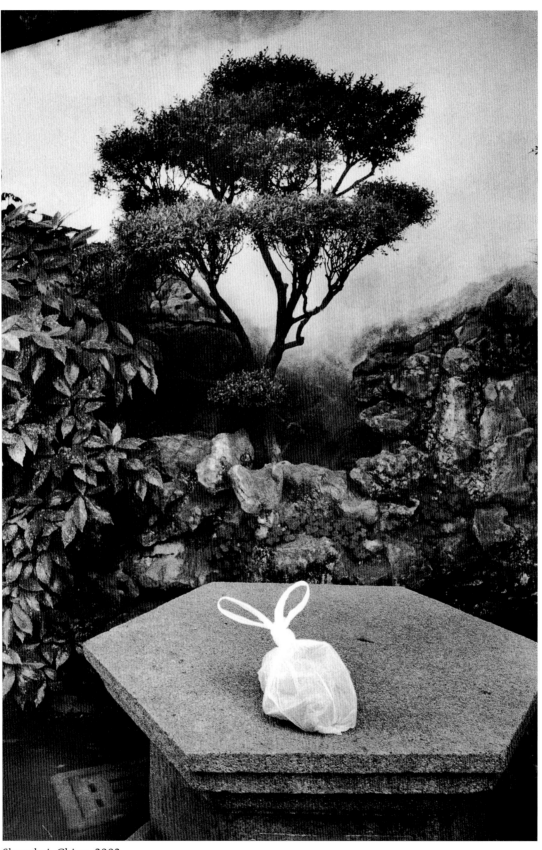

Shanghai, China, 2002

for Road

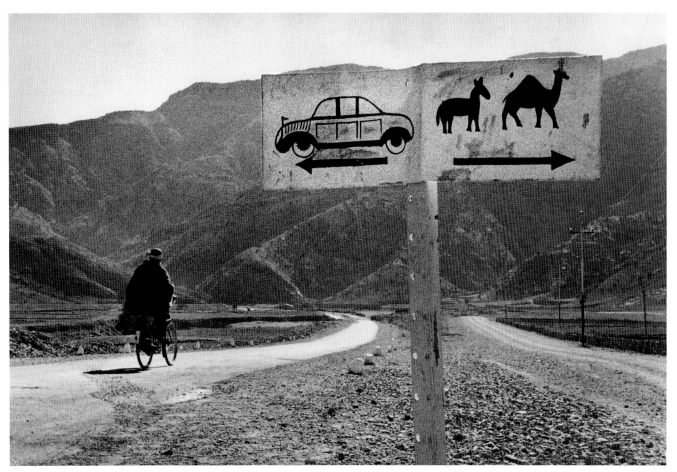

Khyber Pass, Afghanistan, 1955

for Rowing

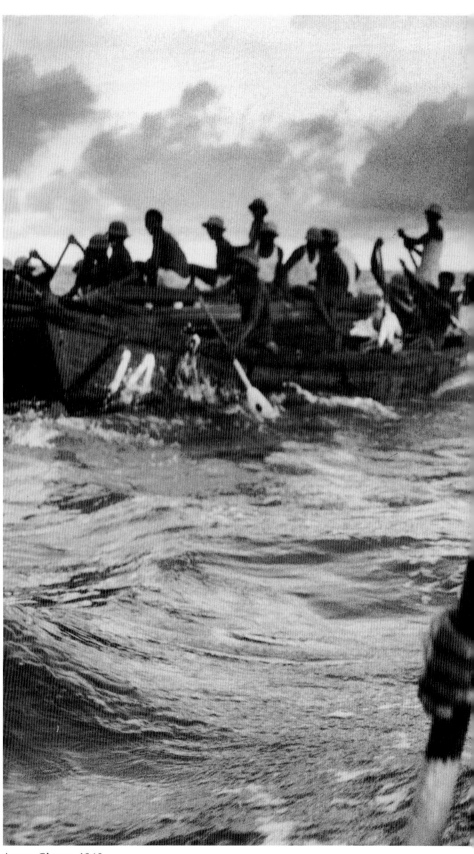

Accra, Ghana, 1960

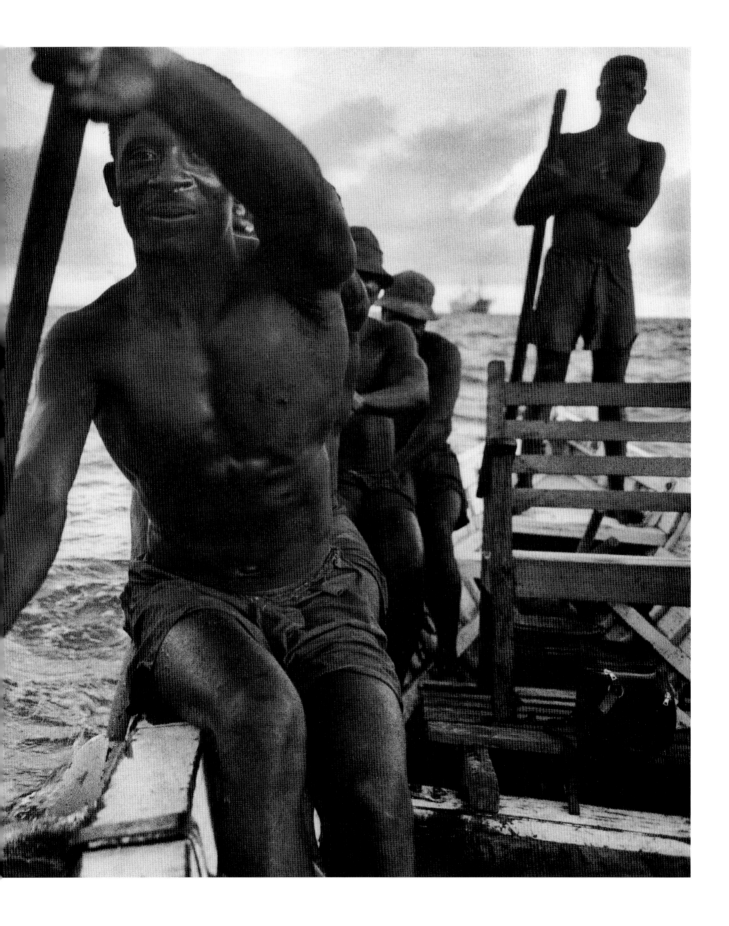

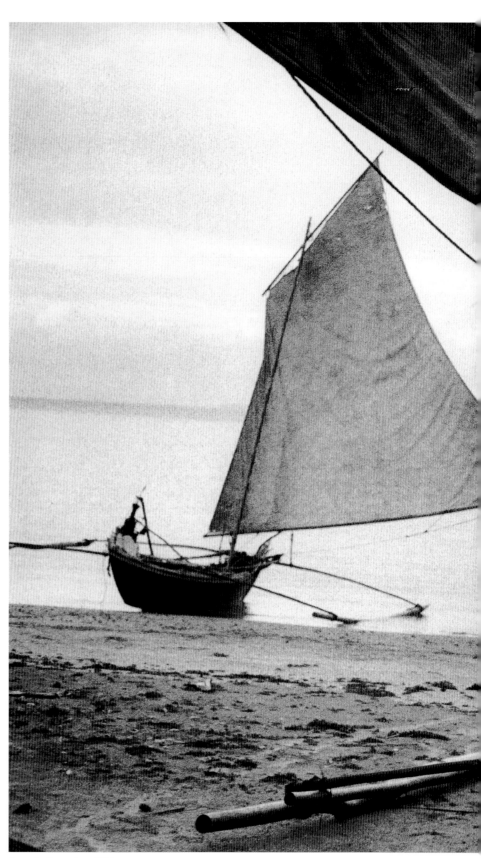

Java, Indonesia, 1956

S for Sail

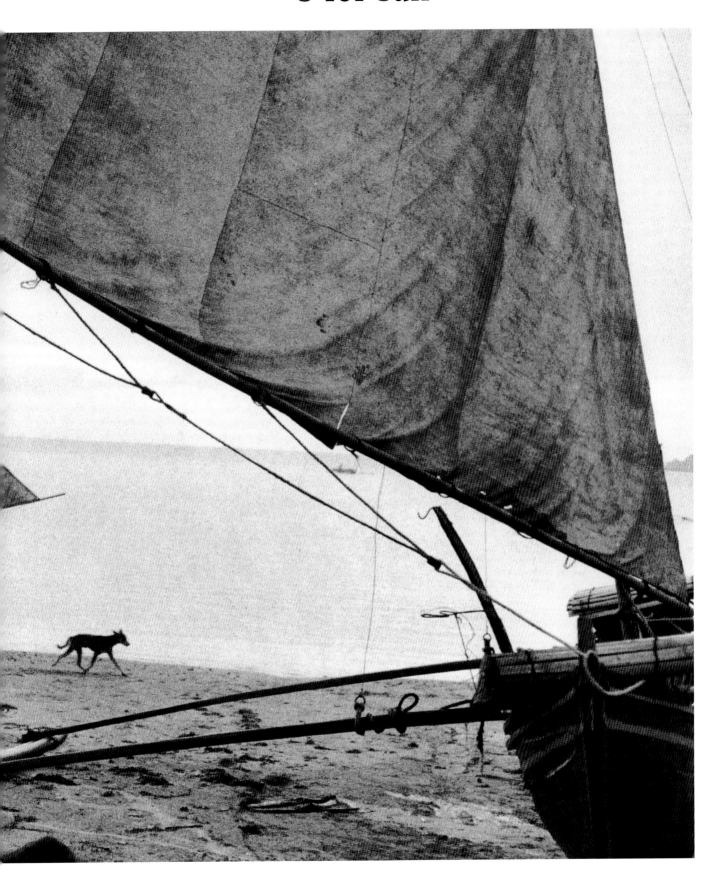

for Shadow

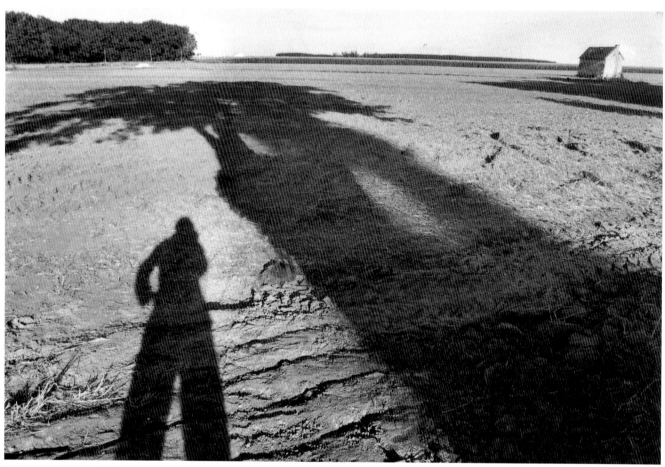

Touraine, France, 2008

for Sad

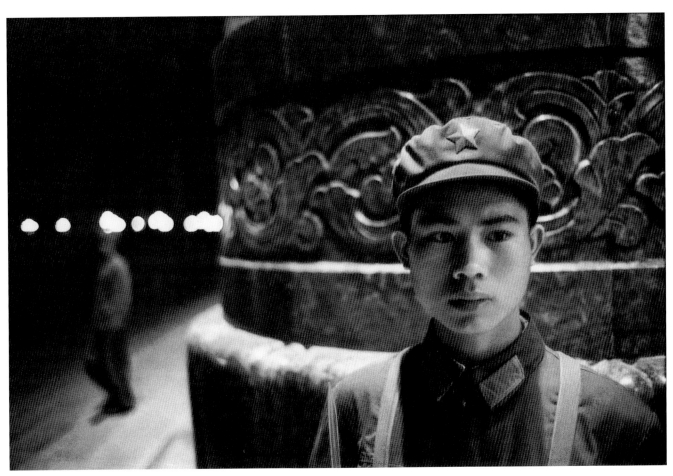

People's Palace. Beijing, China, 1971

for Son

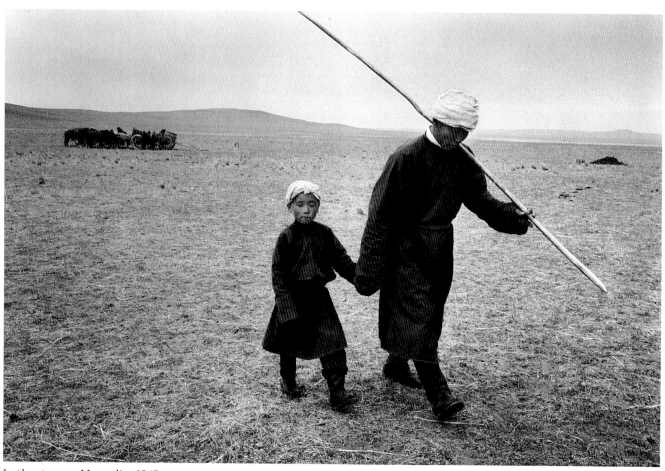

In the steppes. Mongolia, 1965

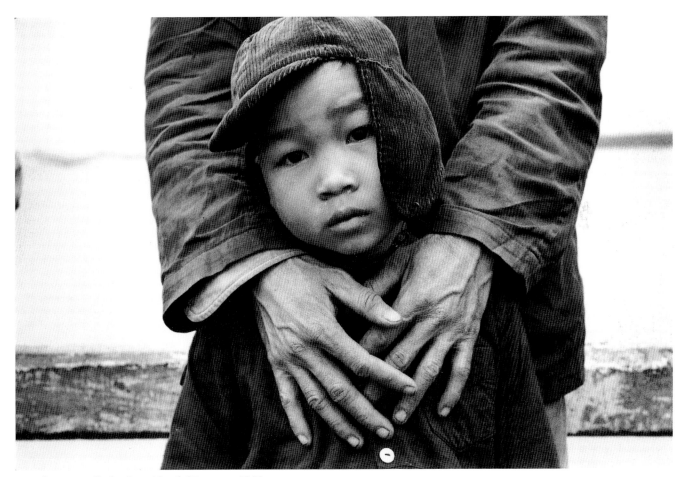

On a boat on a little river. North Vietnam, 1969

for Snow

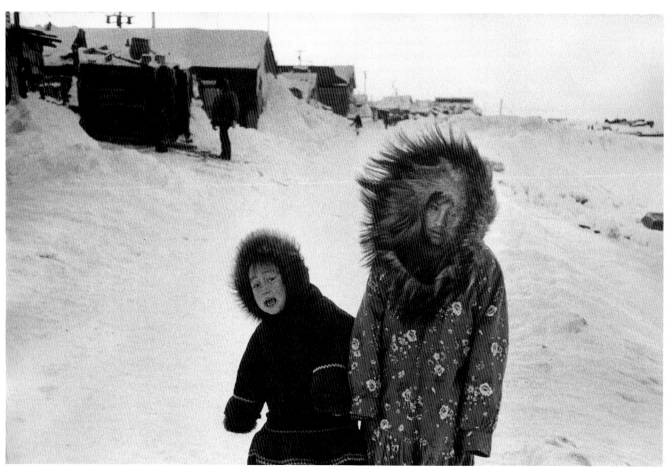

Anchorage, USA, 1959

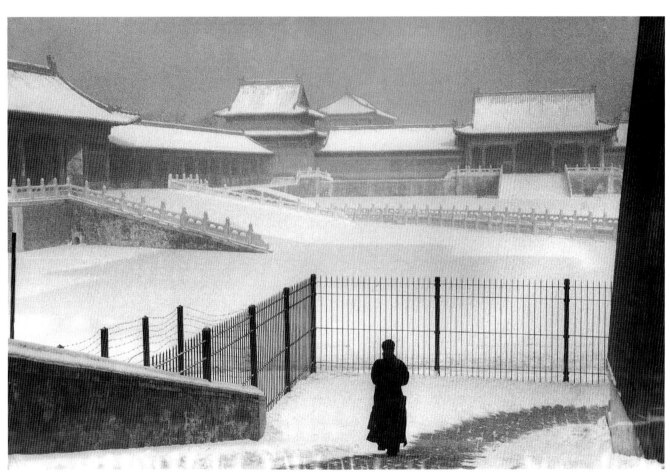

Forbidden City. Beijing, China, 1957

T for Twilight

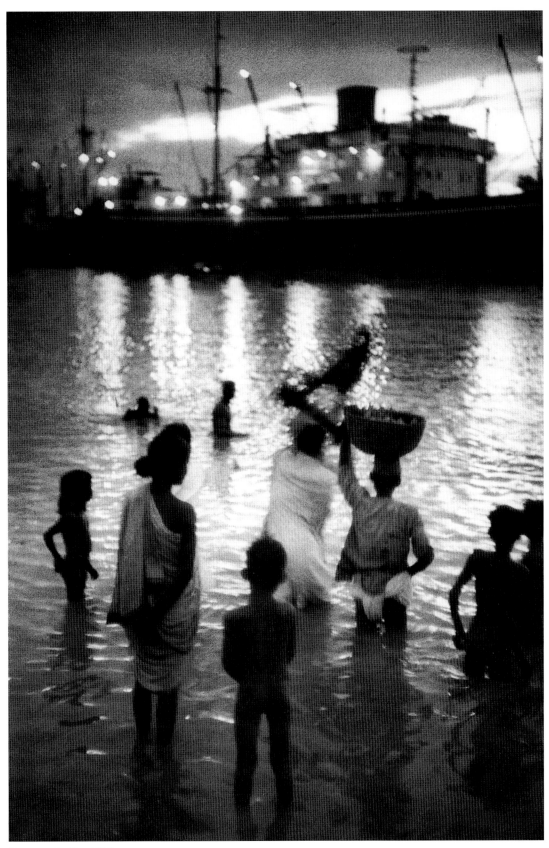

Benares, India, 1956

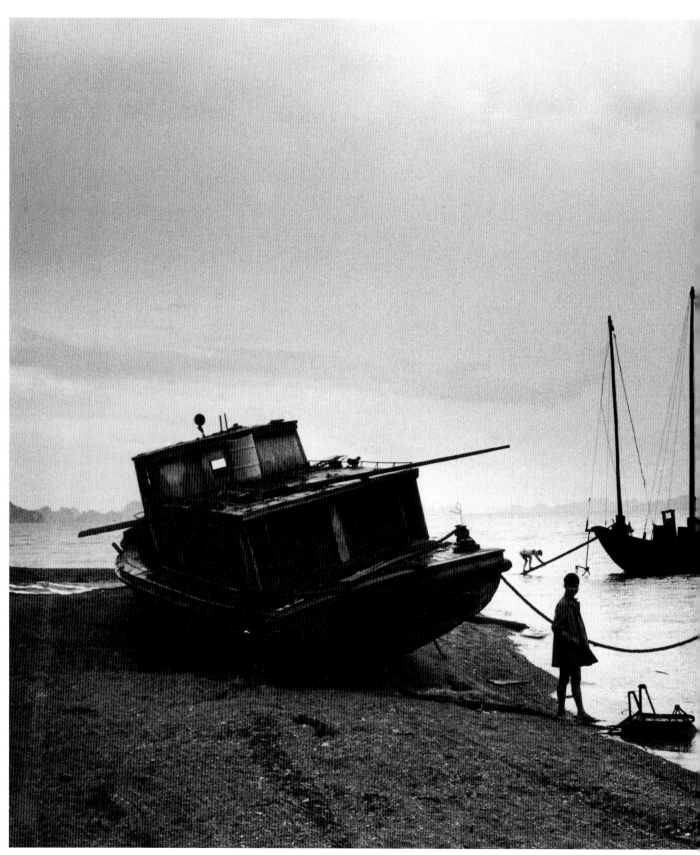

Vietnam, 1969

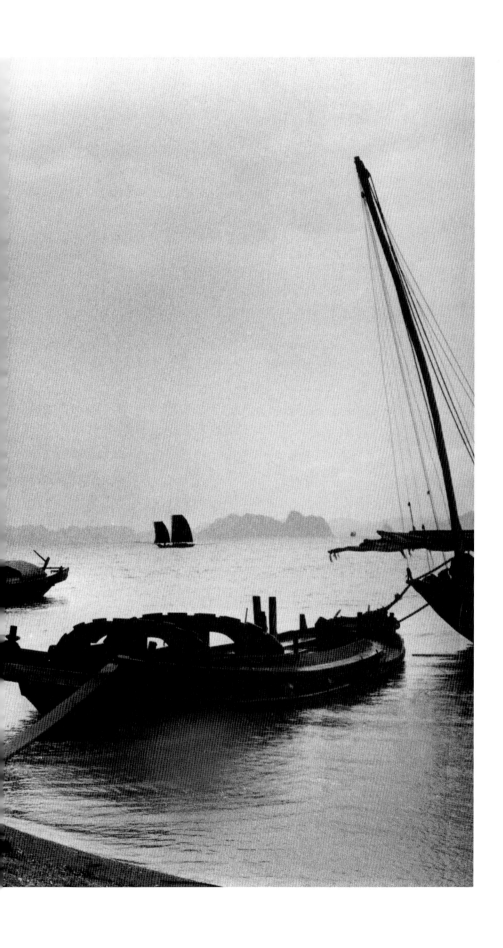

for Turban

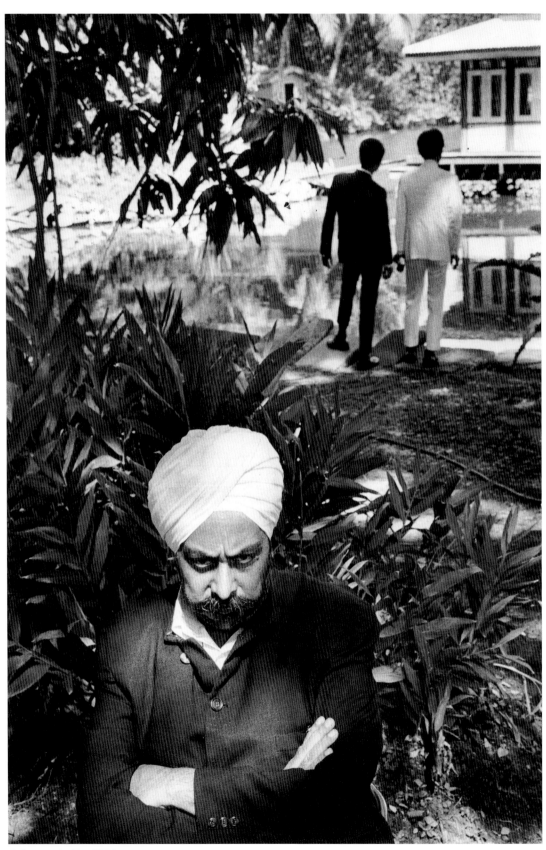

Calcutta, India, 1956

for Turtle

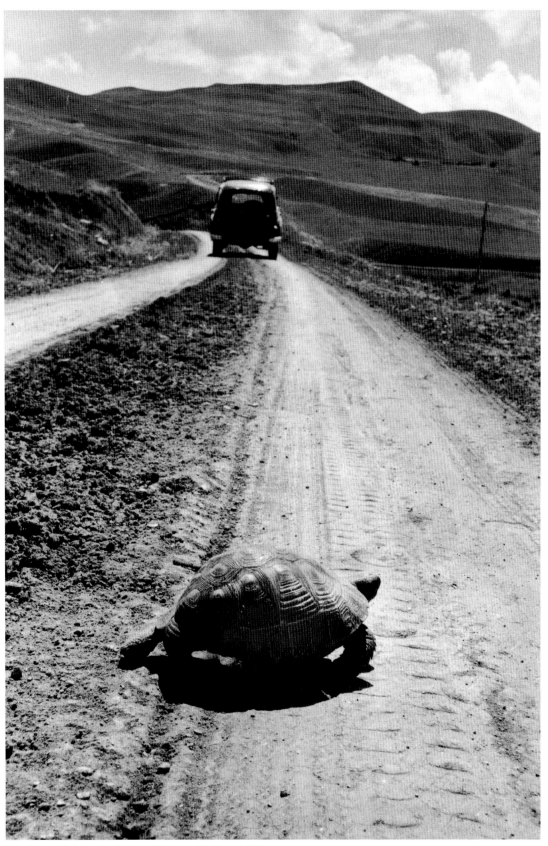

On the road from Ankara to Kayseri. Turkey, 1955

for Tenderness

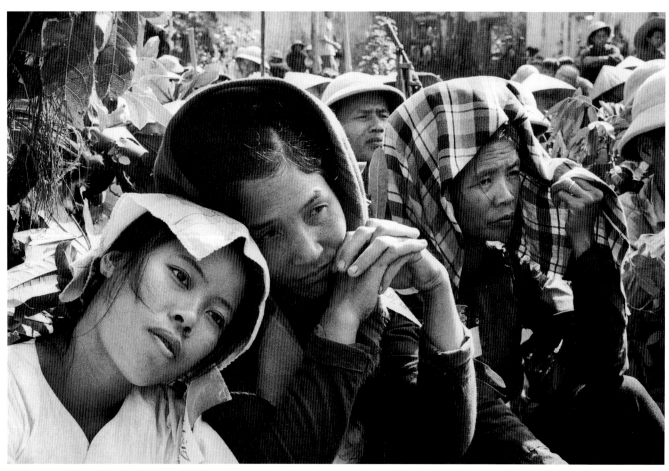

Unknown village, North Vietnam, 1969

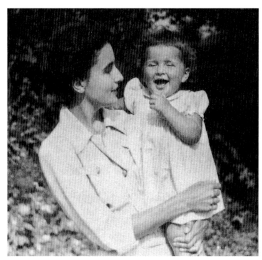

Catherine Chaine and her mother.
Hennequeville, Normandy, 1950

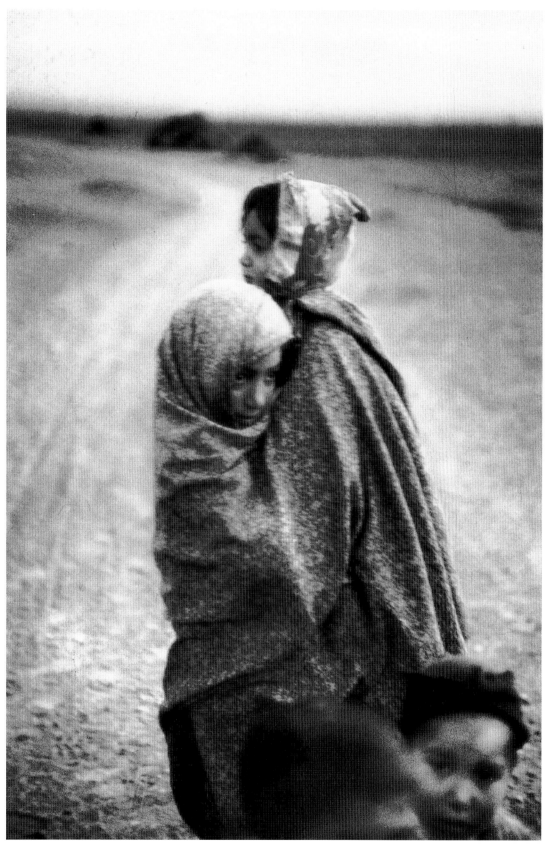

On the road from Tabriz to Teheran. Iran, 1955

U for Unjust

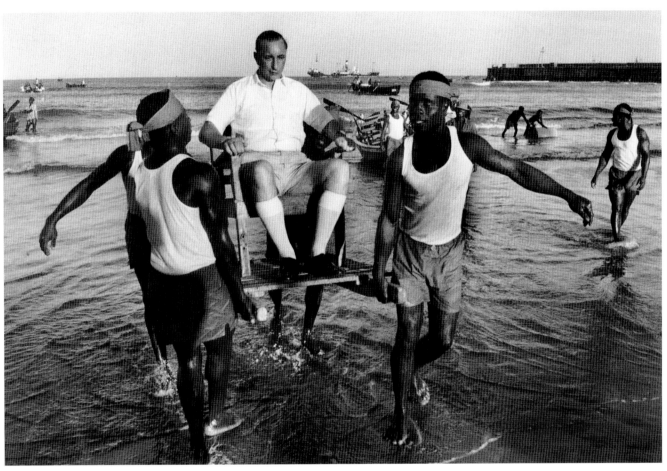

Accra, Ghana, 1960

for Uprising

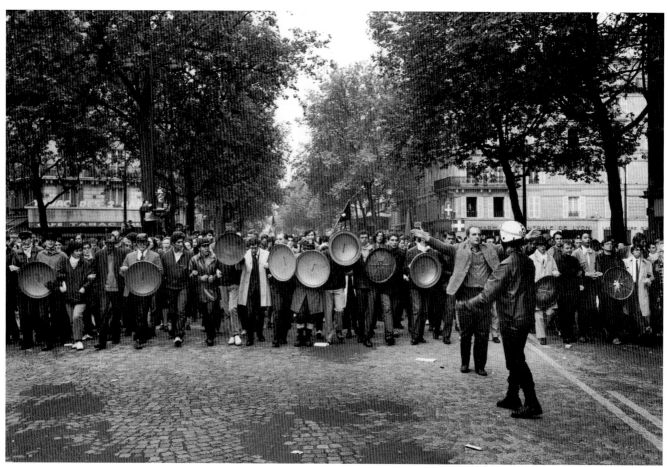

May '68. Paris, France, 1968

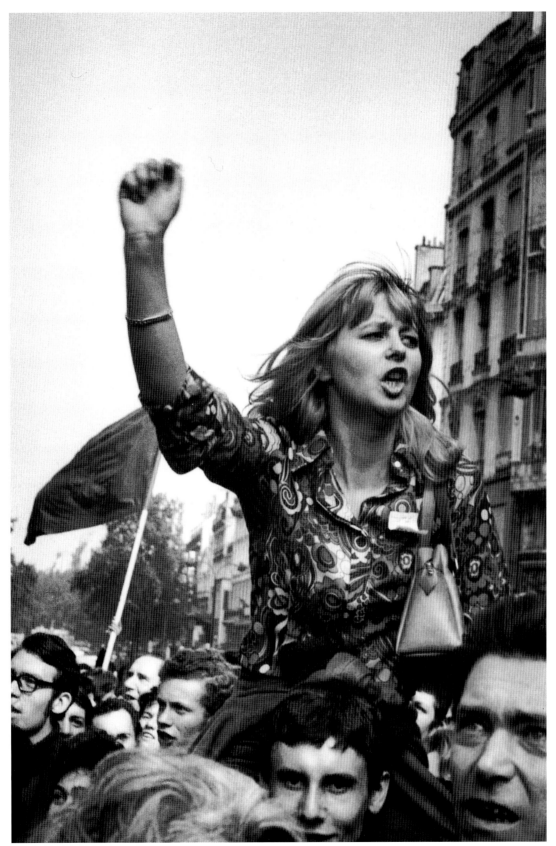

May '68. Paris, France, 1968

for Upperclass

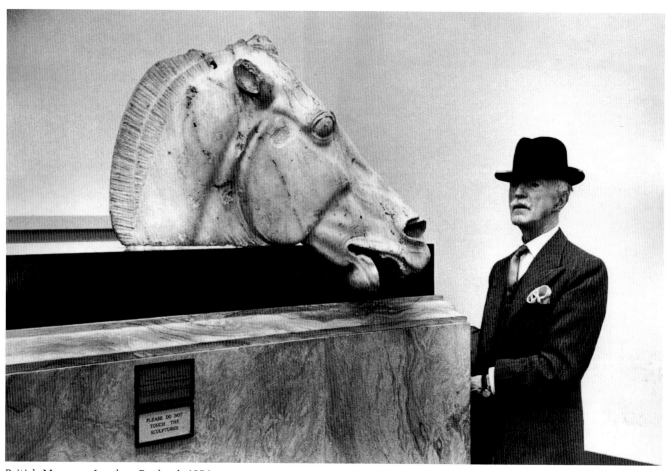

British Museum. London, England, 1954

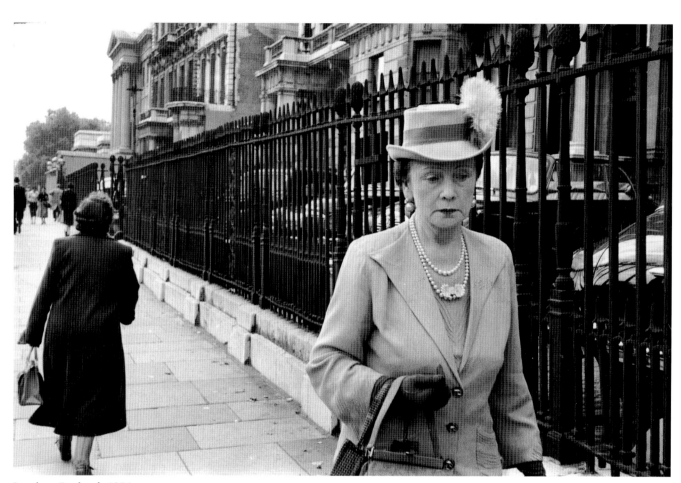

London, England, 1954

V for Veil

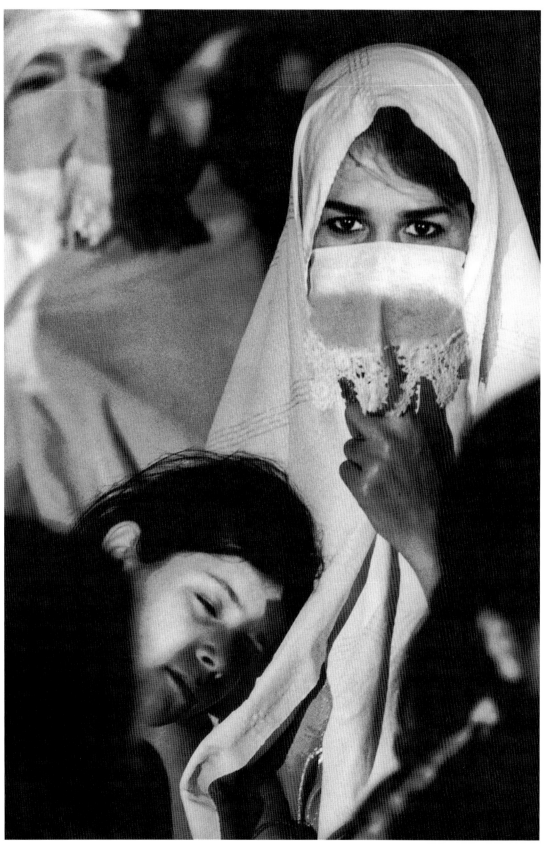

Algiers, Algeria, 1969

for Viewfinder

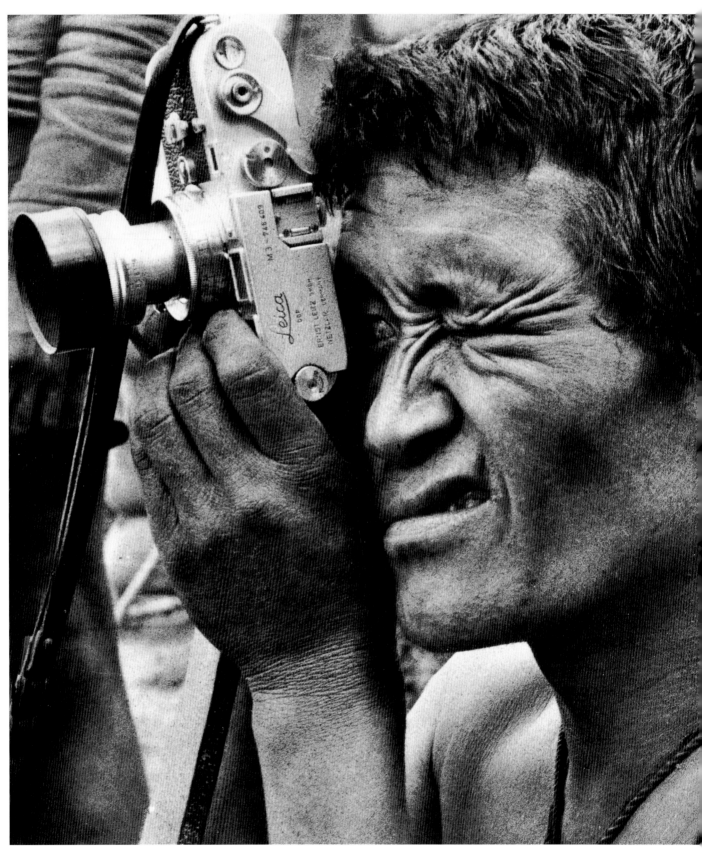

Kathmandu, Nepal, 1956

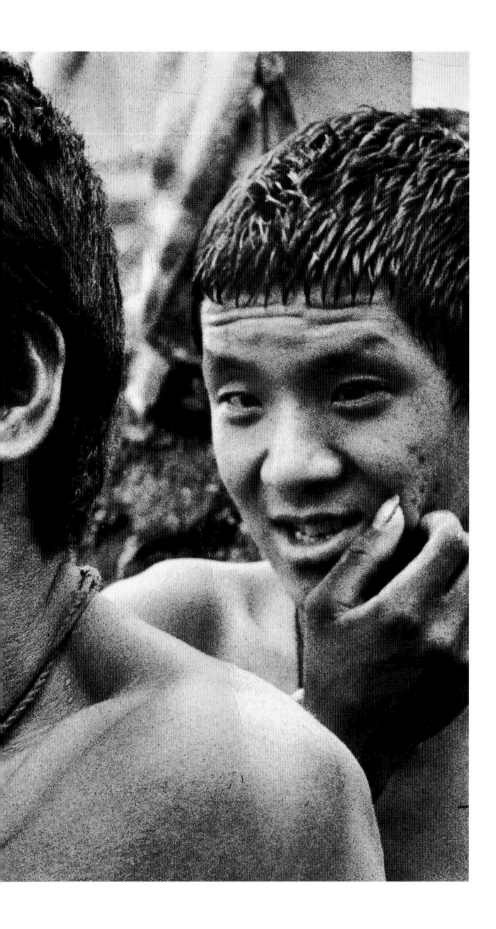

for Victory

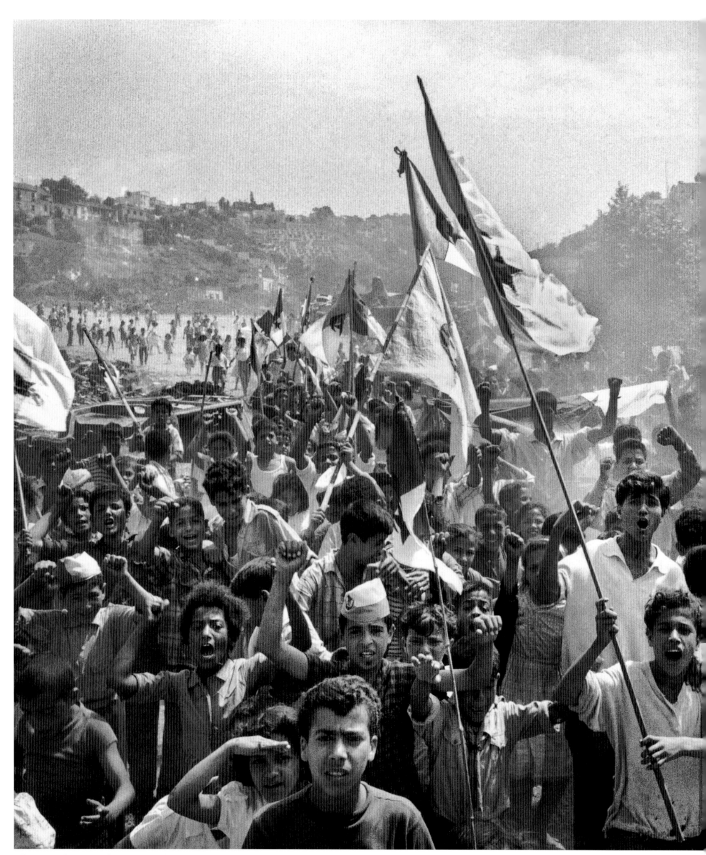

Algiers, Algeria. July 1962, Independence Day.

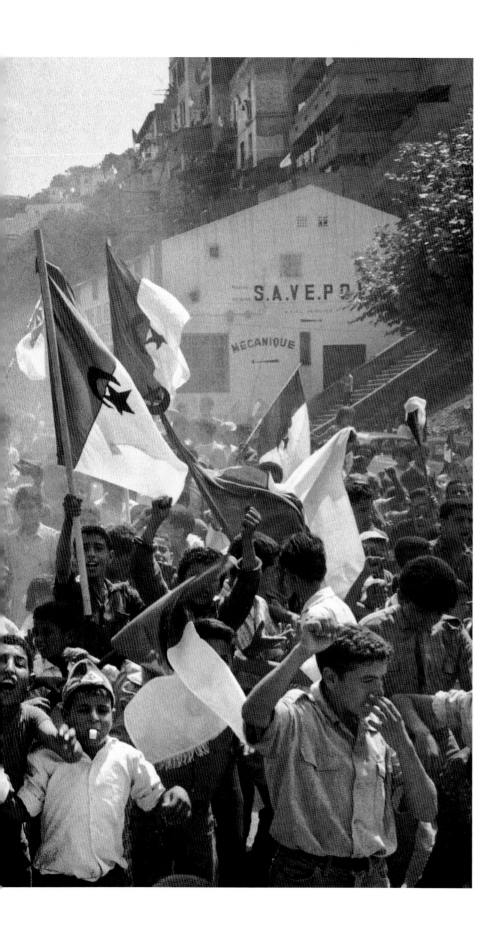

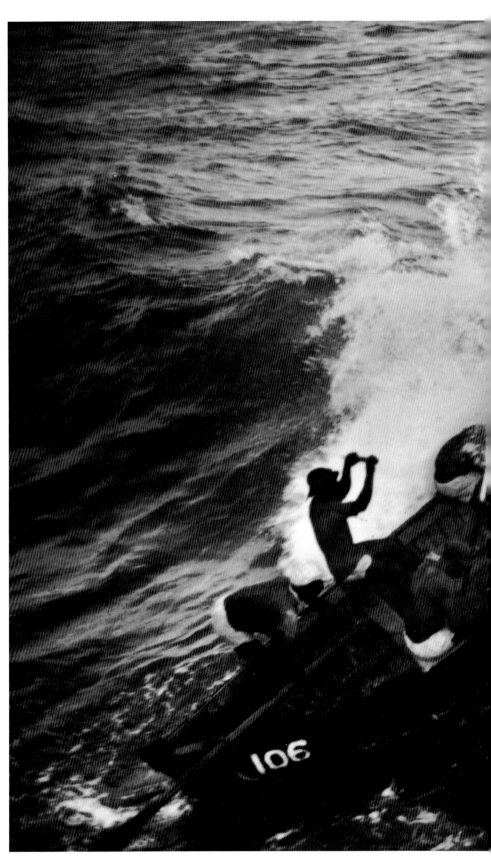

Accra, Ghana, 1960

W for Wave

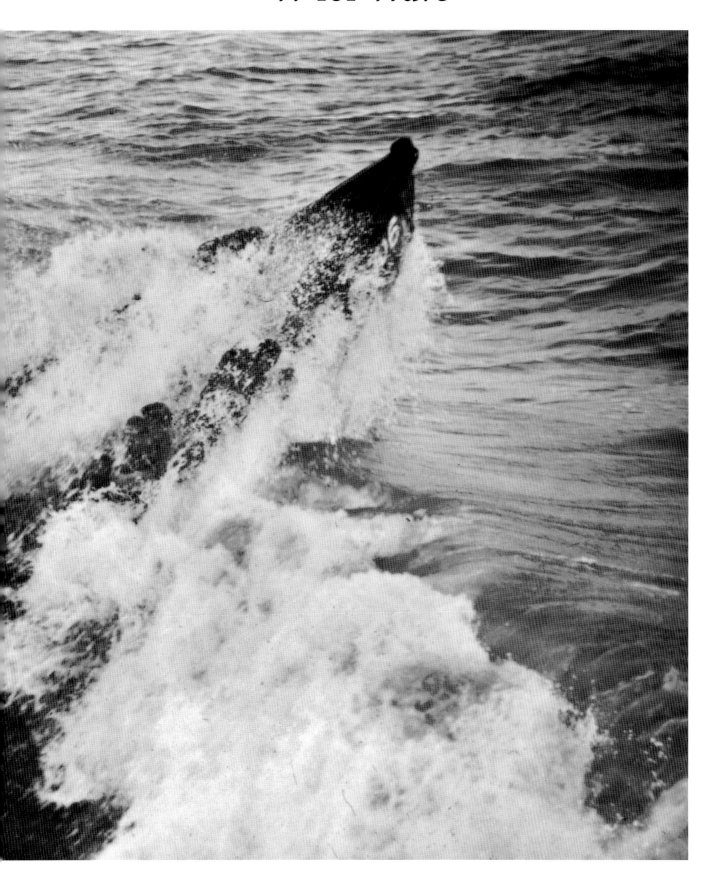

for Windows

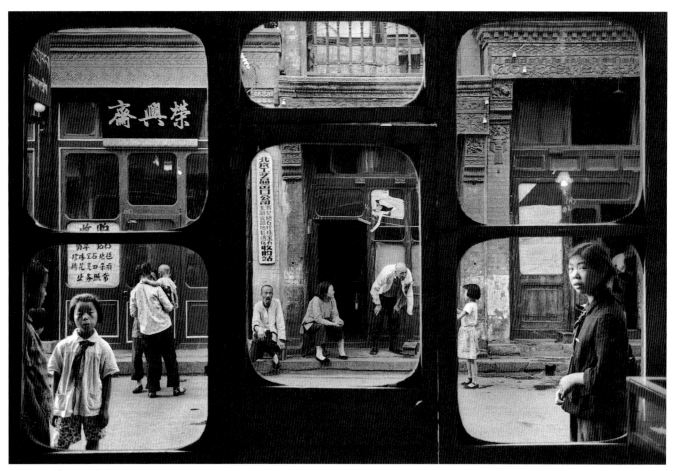

Beijing, China, 1965

for Weight

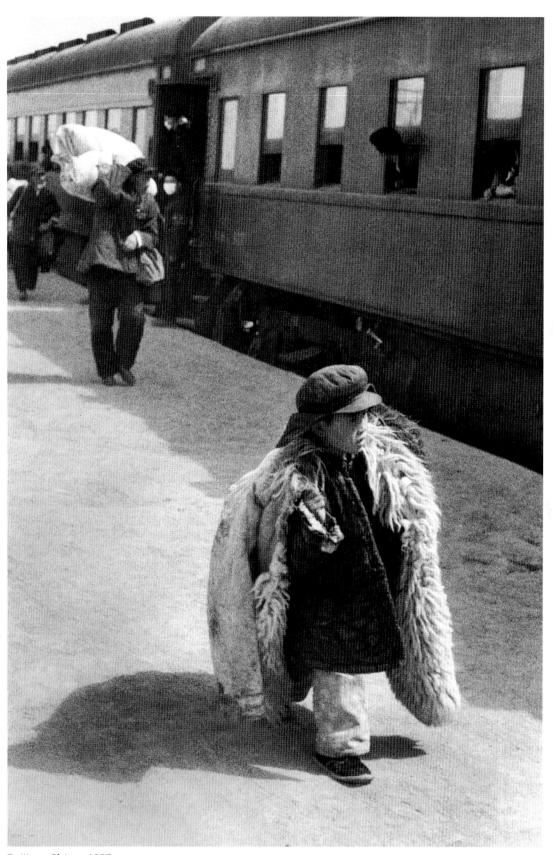

Beijing, China, 1957

X for X

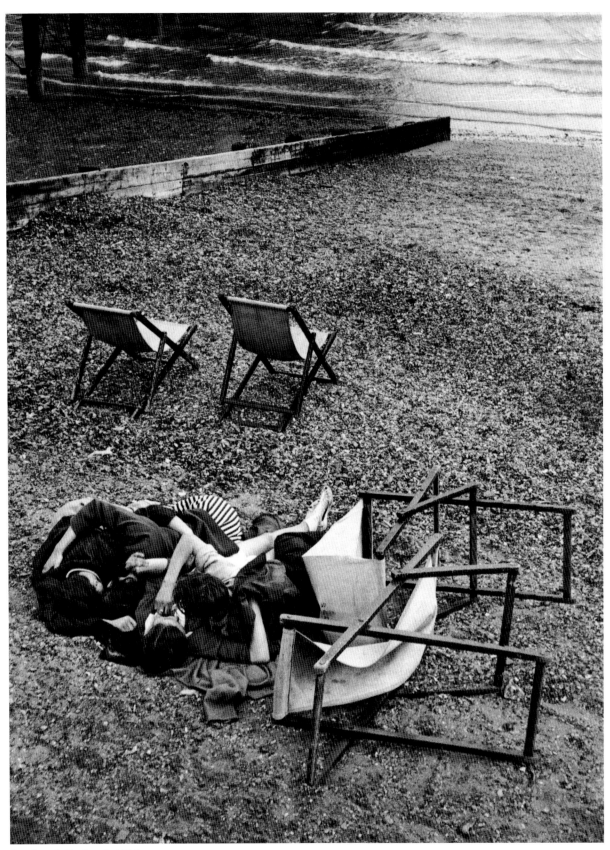

Southend, England, 1954

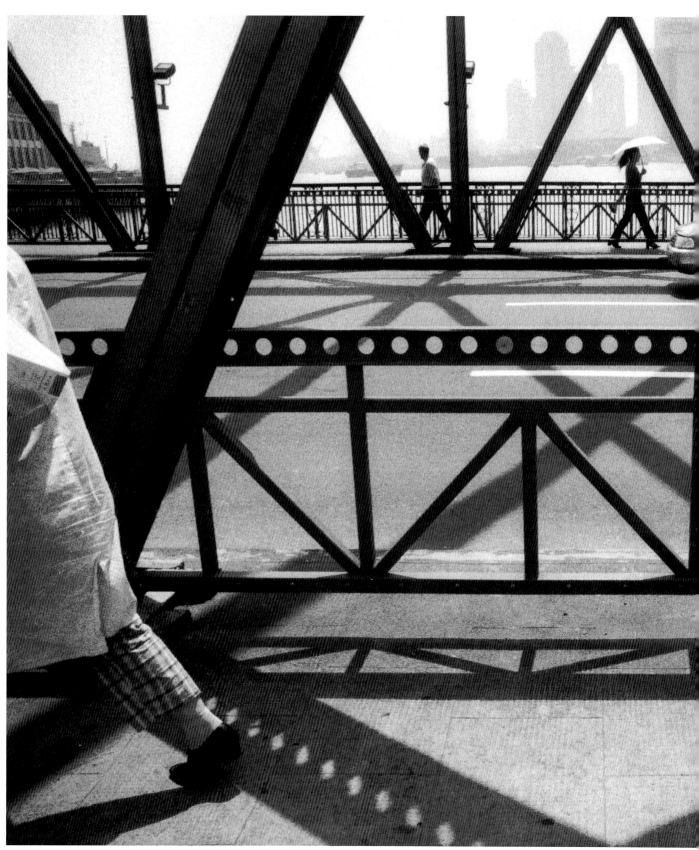

Shanghai, China, 2002

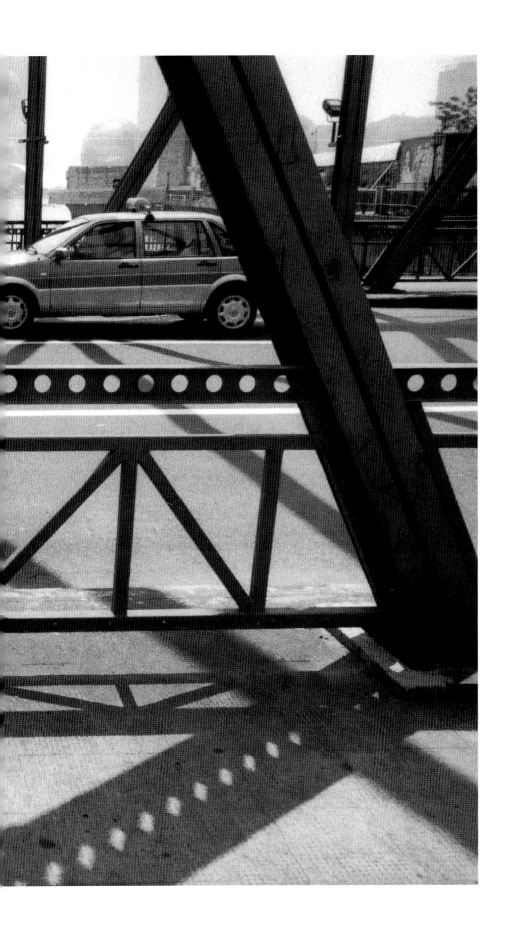

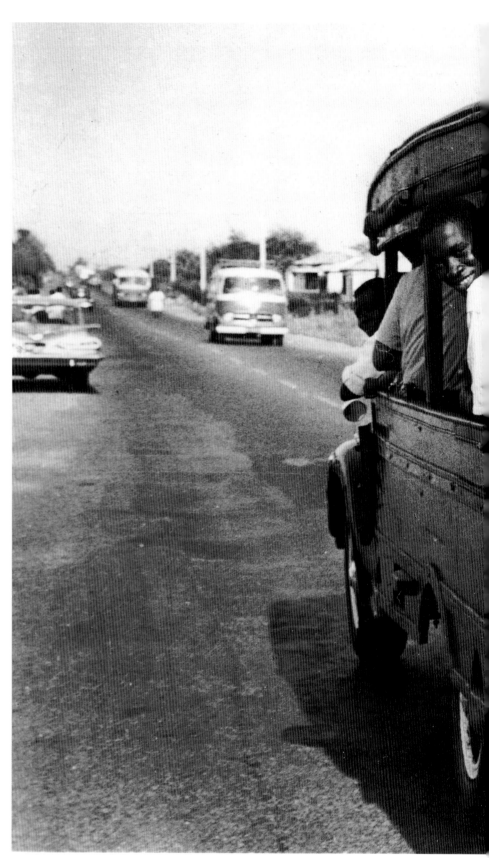

Accra, Ghana, 1960

Y for Young

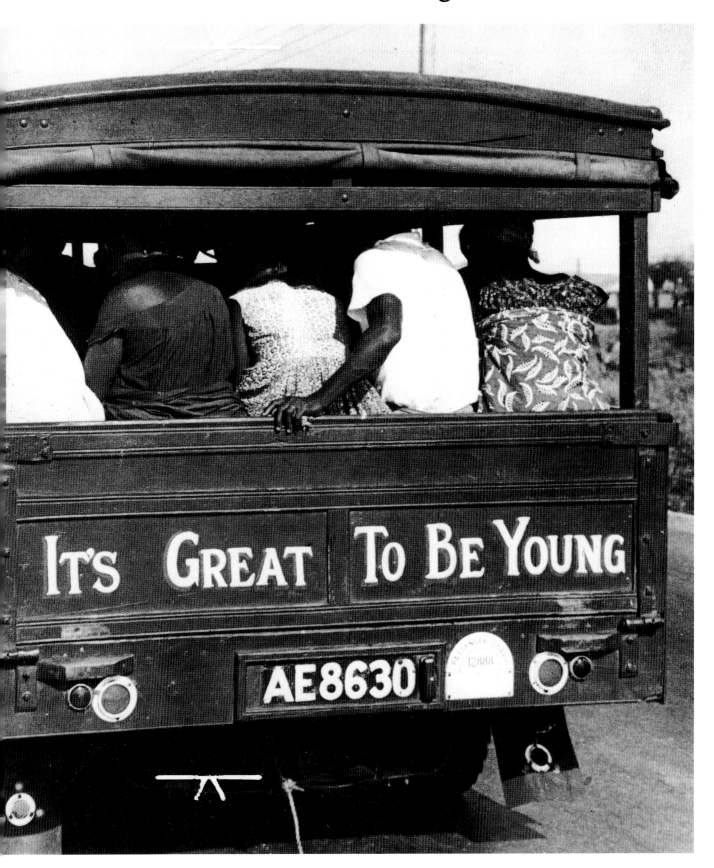

for Yell

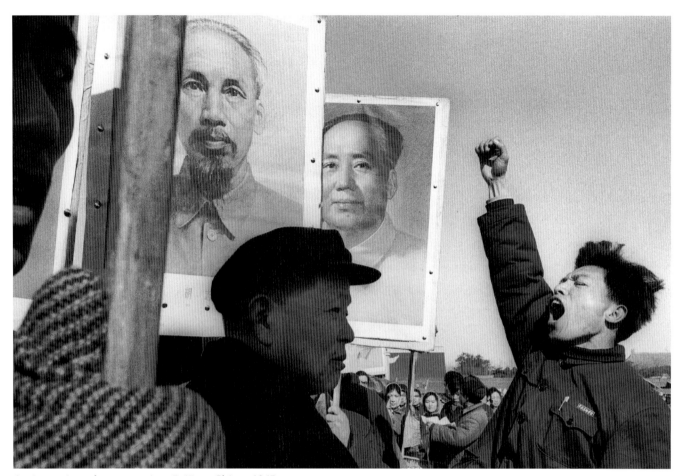

Anti-american demonstration. Beijing, China, 1965

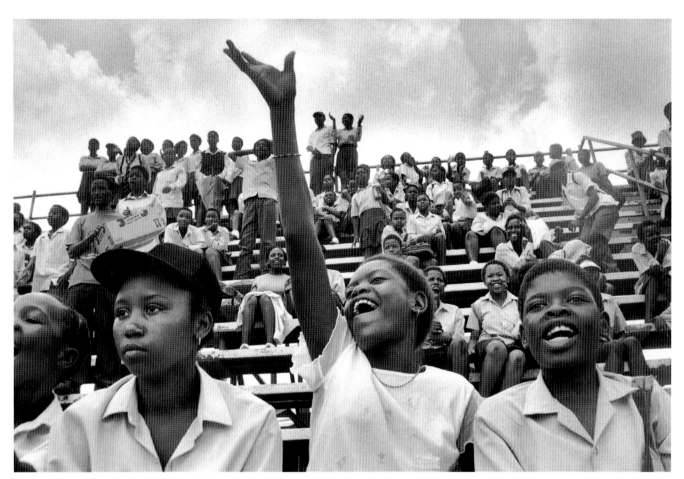

Johannesburg, South Africa, 1998

Z for Zap

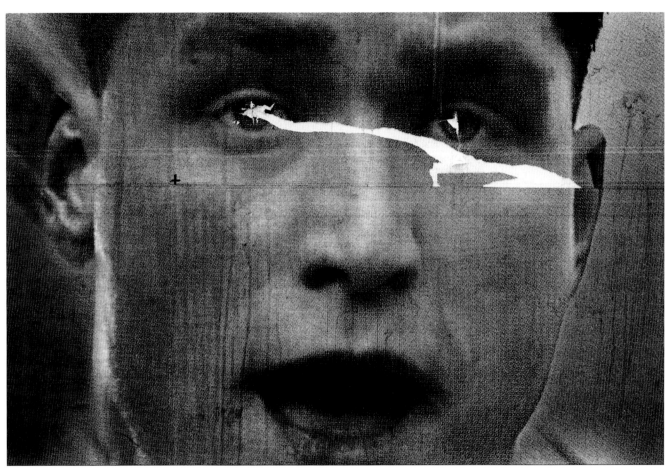

Bratislava, Slovakia, 1994

for Zen

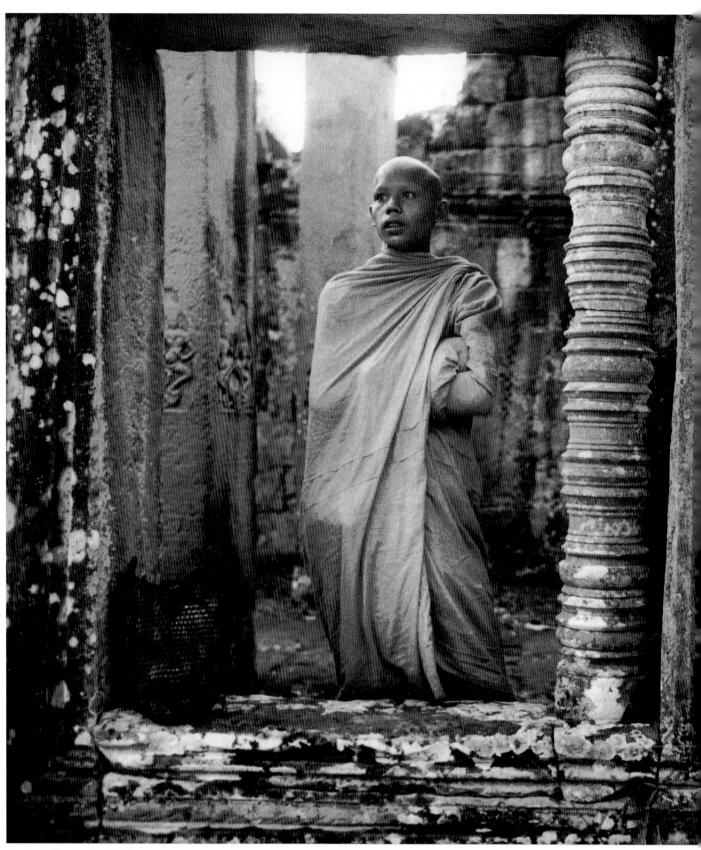

Angkor, Cambodia, 1969

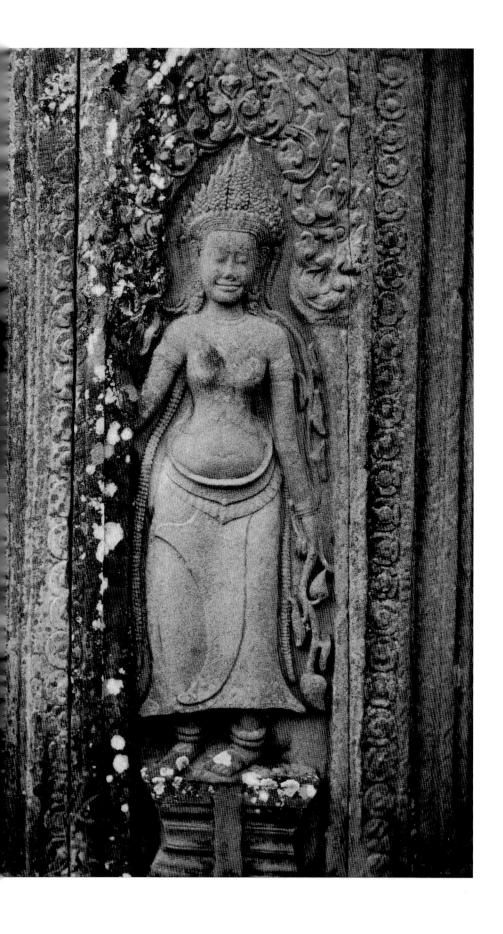

I for Imagine
Copyright © Tara Books Pvt. Ltd. 2010
For the photographs: Marc Riboud
For the introduction: Catherine Chaine
For this edition: Tara Books Pvt. Ltd., India *www.tarabooks.com*
& Tara Publishing Ltd., UK *www.tarabooks.com/uk*

Design: Martin Argyroglo Callias Bey
Production: C. Arumugam
Printed through Asia Pacific Offset, China
Published in association with the French Embassy in India

Photo credits: wherever possible, we have identified the city
and country where a photograph was taken. We have followed
the convention of retaining the names of countries as they existed
at the time the pictures were taken.

With thanks to Small World, our group of publishers, for making this
interaction possible. Les Trois Ourses, France; Petra Ediciones, Mexico;
One Stroke, Japan; Tara Books, India.

ISBN 978-93-80340-10-4

Publisher's Note
French Focus is a new series of visual arts titles published by Tara
Books in association with the French Embassy in India.

Some of the most daring and creative visual books being published
today come from France, and over the years, Tara's books have
found homes with some of the finest French publishers.

We hope to reciprocate with this series, and introduce readers
to our favourites—from art books for adults to picture books for
children, or indeed books that straddle genres and can only be
described as 'Beaux Livres' or 'Beautiful Books'.

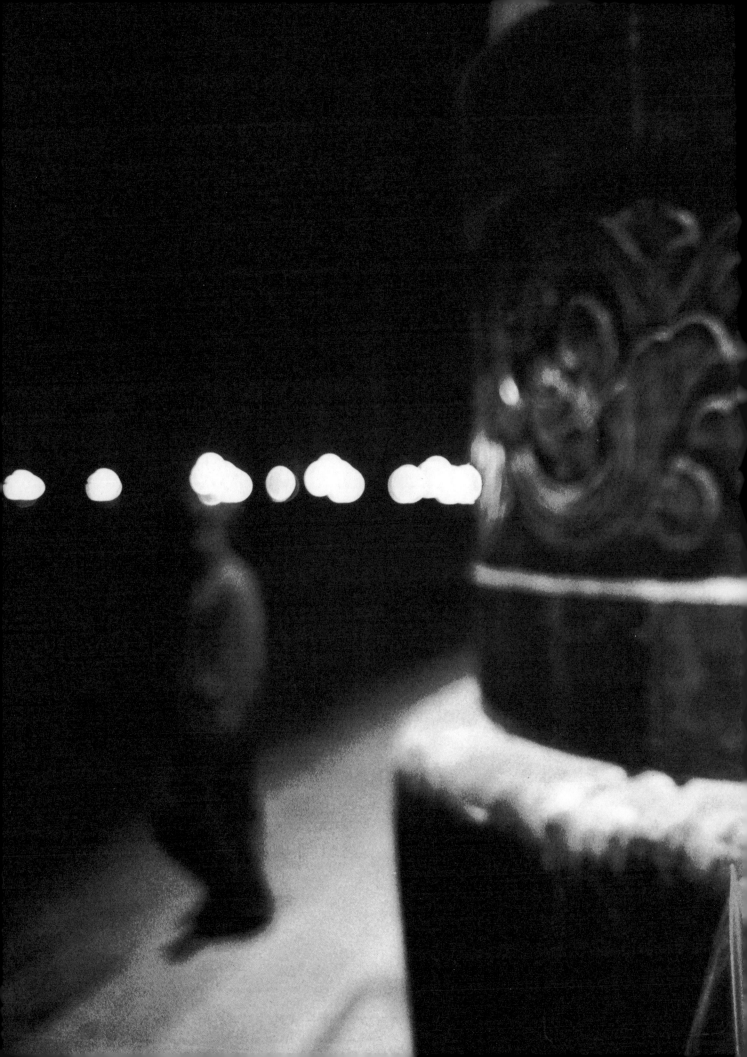